Labradors

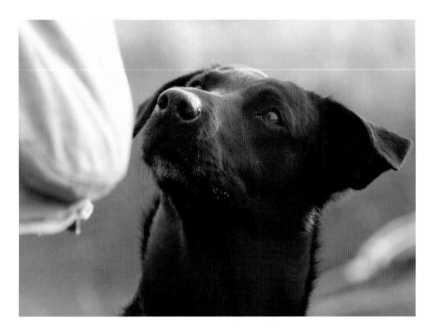

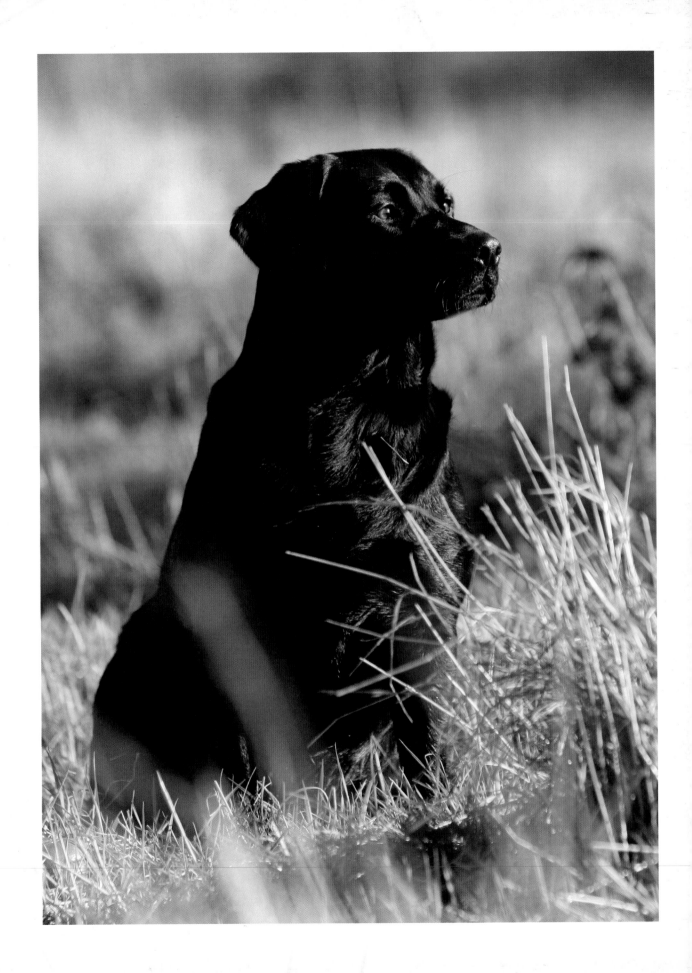

Labradors
WORK, REST AND PLAY

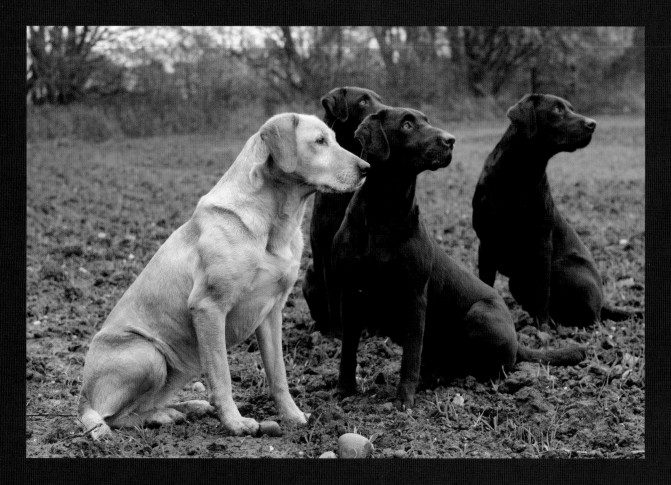

Photographs and text by
NICK RIDLEY

Quiller

Dedication

This book is dedicated to my two beautiful daughters. My eldest Gemma whose love for the written word inspires me to read at least one page of my Oxford dictionary every night before going to bed and Holly with her enthusiasm and stamina for life makes me realise that as I get older I prefer a good night's sleep rather than a good night out!

To both of you…may all your dreams come true.

Copyright © 2008 Nick Ridley

First published in the UK in 2008
by Quiller, an imprint of Quiller Publishing Ltd

British Library Cataloguing-in-Publication Data
A catalogue record for this book
is available from the British Library

ISBN 978 1 84689 049 9

Printed in China

Quiller

An imprint of Quiller Publishing Ltd
Wykey House, Wykey, Shrewsbury, SY4 1JA
Tel: 01939 261616 Fax: 01939 261606
E-mail: info@quillerbooks.com
Website: www.countrybooksdirect.com

Contents

INTRODUCTION

I have been taking photographs of dogs for over twenty-five years and the very first private commission I undertook was of 'Buster' an old but much loved yellow Labrador. He has long gone to the kennel in the sky but his pictures still evoke happy memories for his owners and that is the wonderful thing about my job…capturing memories of our canine companions that last a life time.

If I had a pound for every time a black Labrador owner said to me…'You won't get a good picture of my dog – it is too black' I would be a very rich man indeed, quite what 'too black' means I am not sure, I always thought black was black.

When I first thought about writing this book I hadn't realised how many images of Labradors I have archived, in fact it is close to 40,000 and scanning through the library it became very obvious to me that the Labrador Retriever has to be one of the most versatile creatures on this earth. He is a hunting companion, he can be the eyes and ears of his owner, he can open doors, he can detect drugs, explosives and even forged money. He can guard, he can jump, he can swim, his puppies are the cutest and I think he epitomises the statement of being 'Man's Best Friend'.

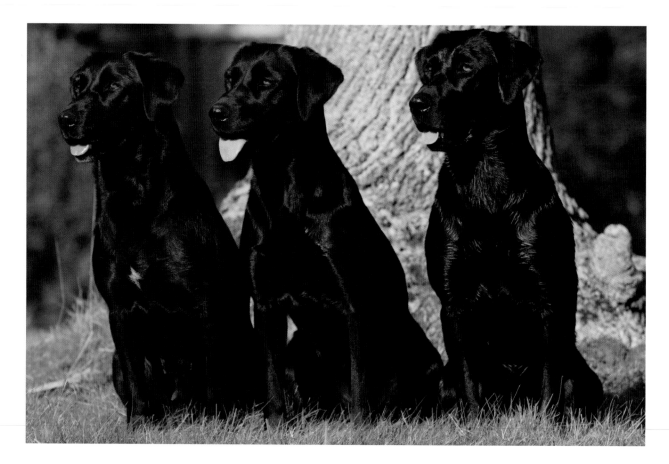

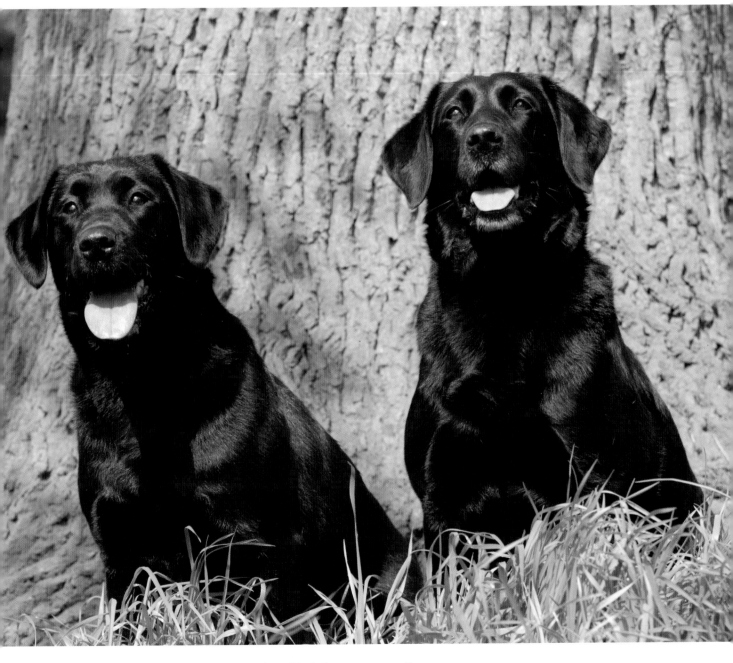

Fortunately I don't have trouble photographing black dogs...just as well.

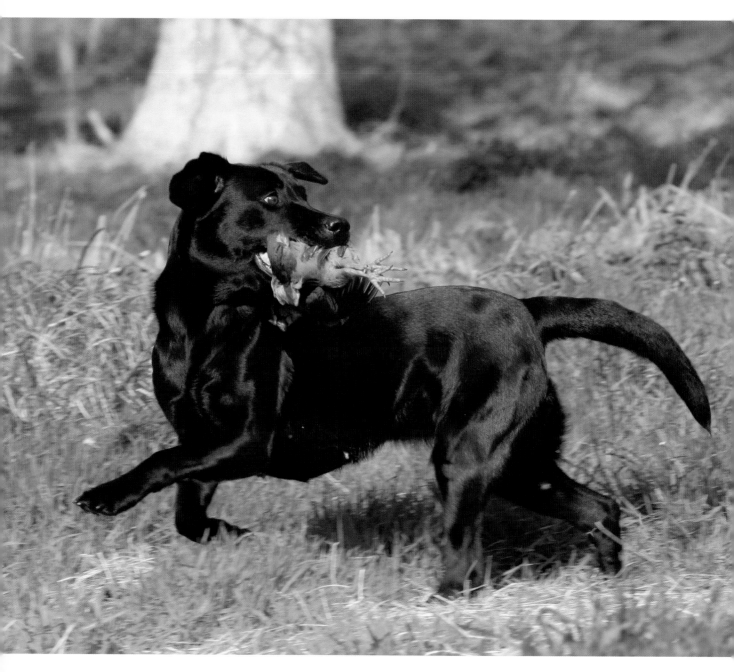

'I'll get that one later...!'

RIGHT: There is a very special bond between this dog and his owner.

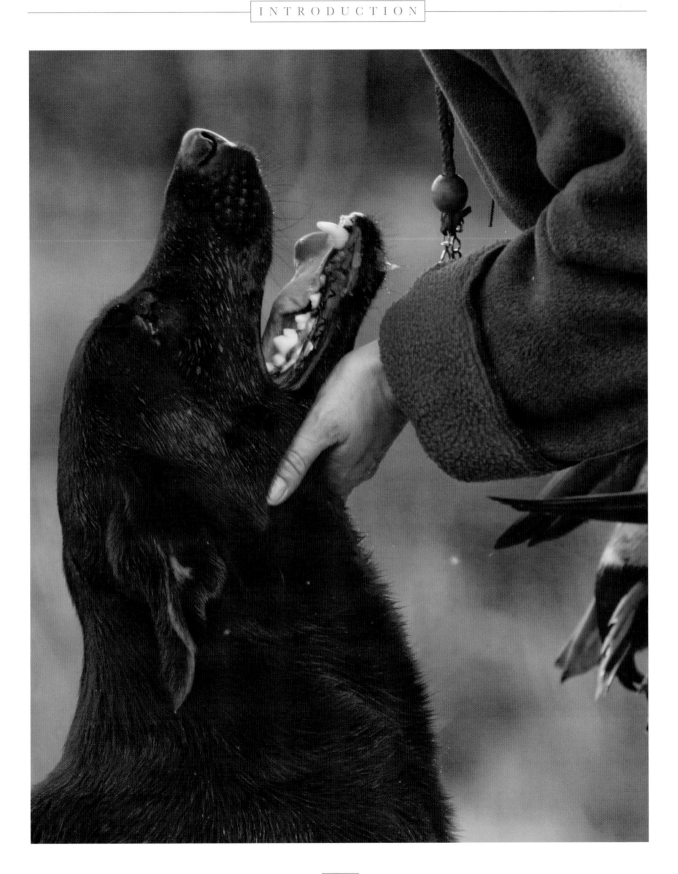

Over the past few years the breed has constantly been at the top of both the USA and UK Kennel Club registrations and not by just a small margin. In 1997 the Labrador had more than twice the registrations of its nearest rival. Fortunately this is not because the breed has become the latest fashion accessory or a passing fad – it is purely in recognition of the dog's versatility and its ability to adapt to many kinds of work and of course its role as a loyal member of the family. One of the greatest pleasures that I get from my job is when someone asks me to photograph their dog as it is getting old and they have never been able to get a good picture and I manage to capture the personality of that dog and the owner goes away with a treasured memory.

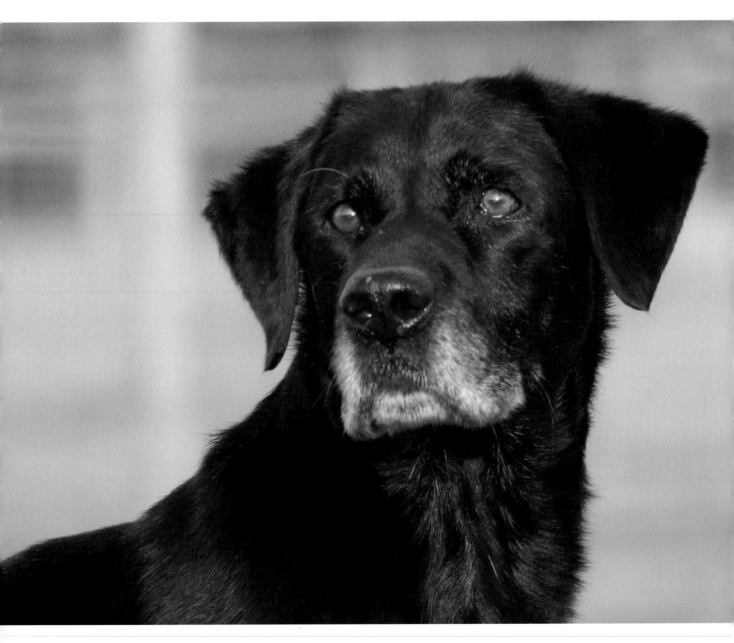

Old, wise and just a little grey...

1. WORKING LABS

Throughout history Man and his Dog have hunted the wide-open spaces and dense woodlands for food and over the years certain breeds were selectively bred to do specific jobs and it is no different with the Labrador retriever.

This book was never meant to be a history of the breed as there are plenty of publications that cover the facts and dates far better than I can but any book on the breed would not be complete without mentioning the Buccleuch Labrador.

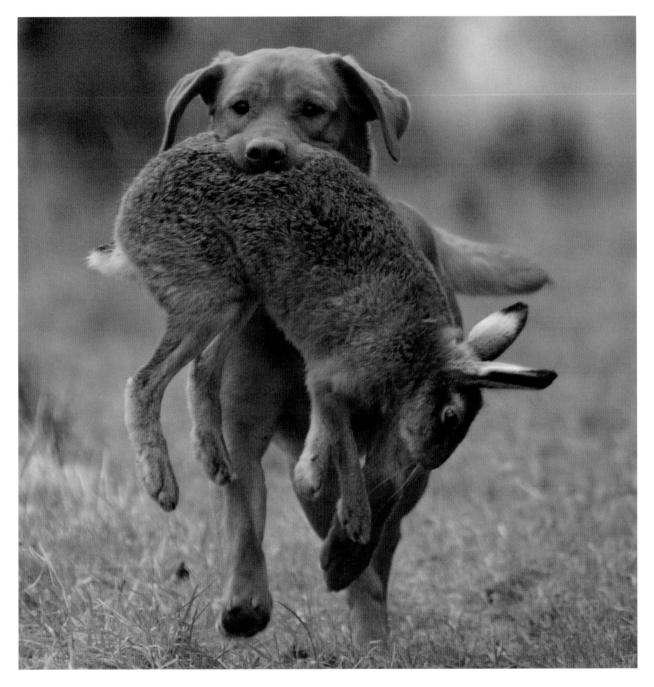

Even a large hare is not too much for a strong Labrador to retrieve.

The Buccleuch Labrador

In the 1830s, Walter Francis Montagu-Douglas-Scott, the fifth Duke of Buccleuch, was one of the first to import dogs from Newfoundland on to his estates in the Scottish Borders for use as gundogs because of their excellent retrieving capabilities.

Another advocate of these marvellous Newfoundland dogs, or Labrador retrievers as they later became known, was the second Earl of Malmesbury who bred them for use in duck shooting on his estate at Heron Court on the south coast, particularly because of their acknowledged expertise in waterfowling, their 'close coat which turns water off like oil' and a tail 'like an otter'.

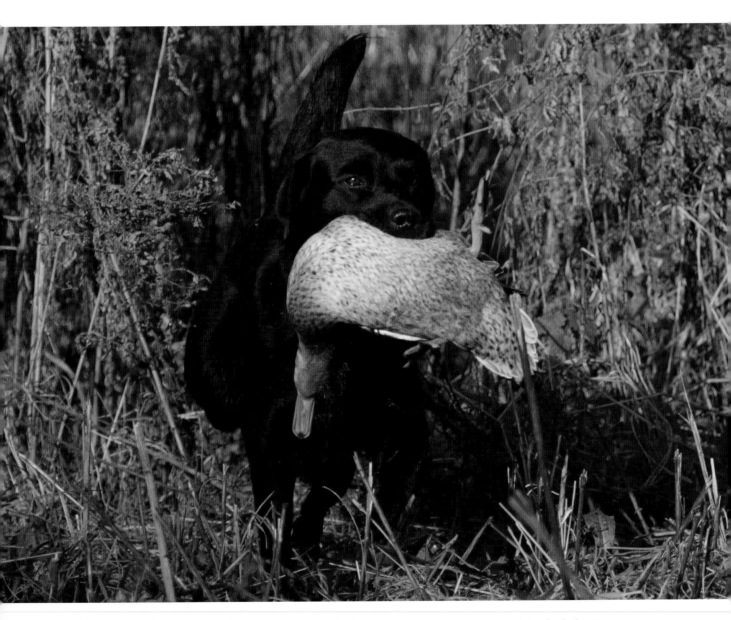

The original Newfoundland dogs, later known as the Labrador retriever, were first bred for duck shooting.

In the early 1880s, the sixth Duke of Buccleuch and the third Earl of Malmesbury met while shooting and the first two entries in the Stud Book of the Duke of Buccleuch's Labrador retrievers were in fact the gifts made by Lord Malmesbury to the sixth Duke. When these dogs were mated with bitches carrying blood from those originally imported by the fifth Duke, a strong bloodline was developed beginning with Buccleuch Ned in 1882 and Buccleuch Avon in 1885. In fact, the Buccleuch Kennel is almost unique in as much as the original pure strain has thus far been strictly maintained since the breed reached these shores in the 1830s. All Buccleuch Labradors can be traced back to those first imported dogs.

While Buccleuch Labradors were never actually trialed, being bred entirely for 'work' purposes, the bloodline has formed the ancestry of many champions over the years, including the first Labrador to be placed at a retriever trial in 1906 (FTCH Flapper). The main characteristics of the traditional Buccleuch Labrador are a good nose, a tender mouth and an intelligent and courageous temperament. Their heads are often shorter than the average Labrador, they have a thick double coat and frequently have the 'otter' tail. The pure strain can only throw black puppies.

By the 1920s the kennel contained 150 dogs. However, the seventh Duke was not active in maintaining the line and no new dogs were imported between 1890 and 1930 due to a Sheep Protection Act in Newfoundland and the introduction of quarantine restrictions. The advent of war in 1939 and a distemper epidemic in 1948 took their toll on the kennel leaving it substantially run down. Some progress was made at this time by the Earl of

FTCH Buccleuch Opal known as Moss can trace her ancestry back to the original Buccleuch Labradors.

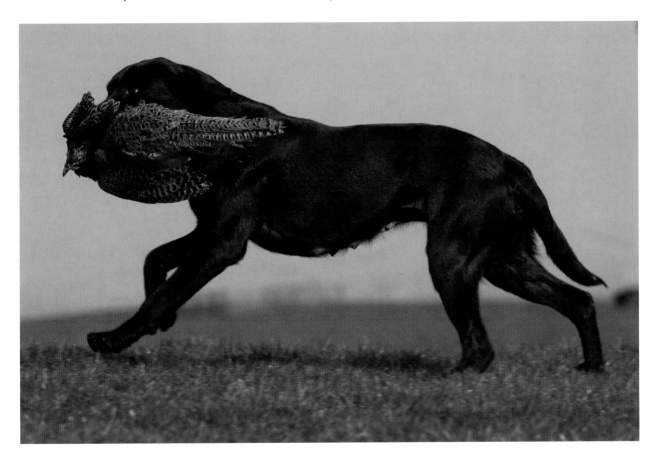

Dalkeith (later ninth Duke) along with a full-time dog handler and much use was made of Vaulter, a dog displaying the old characteristics of a broad head, thick double coat and short otter tail and many of today's Buccleuch Labradors can be traced back to him.

There is more to this story than just a series of dates. I had the pleasure of spending a week at the Buccleuch Kennels photographing their dogs in action and one in particular Field Trial Champion Buccleuch Opal, known, as Moss is a very special dog indeed. Moss's pedigree can be traced right back to the original 1830 Buccleuch lines and is the first Buccleuch Labrador that has ever been field trialed. In fact she achieved Field Trial Champion status in just fourteen months from winning her first trial: this is no mean achievement and can surely be contributed to her historic breed lines and the dedication and skill of her trainer.

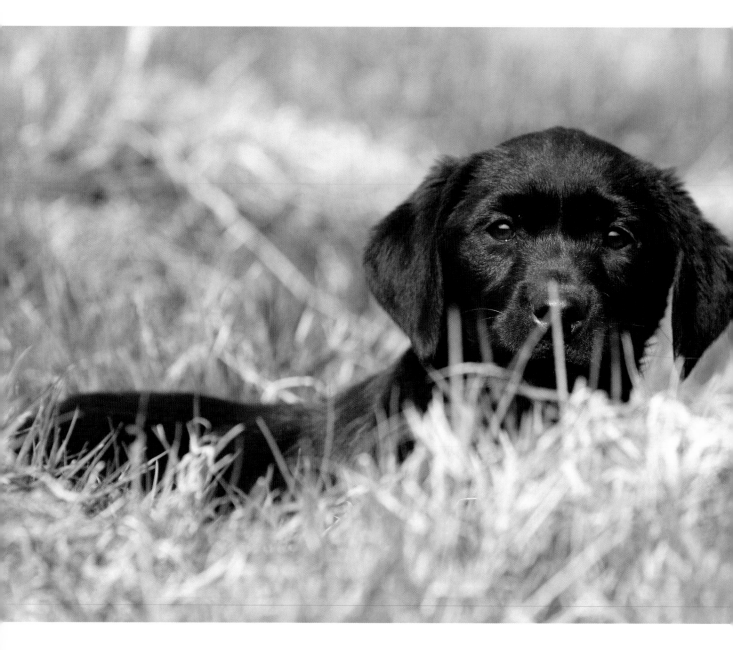

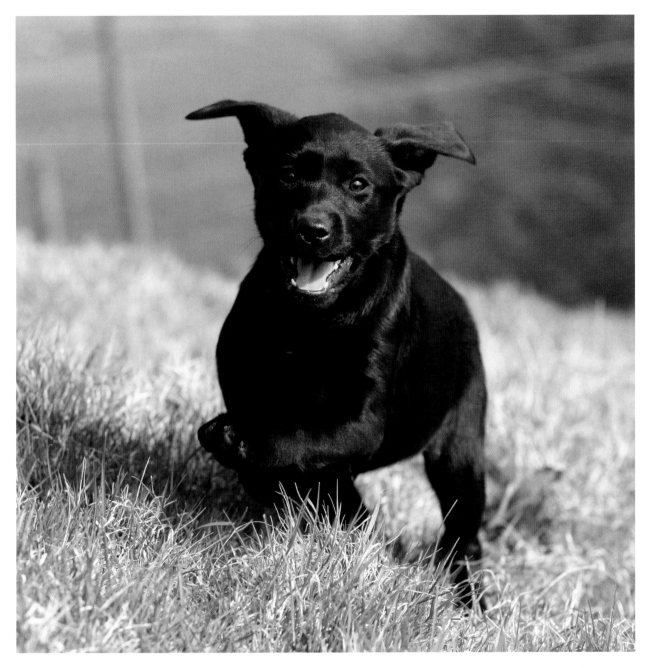

The latest generation of Buccleuch Labradors...there is a lot of responsibility riding on these pups' young shoulders.

In the field

I am passionate about gundogs and gundog work and whenever I am in the field photographing the dogs doing what they have been bred to do, I consider myself very lucky indeed. Over the years I have been fortunate to attend some of the highest profile field trials and working tests in the UK and to see the best of the best compete against each other is a joy to behold. A Labrador is born to retrieve and from its earliest days it will gladly run around with whatever it can get in its mouth.

This natural ability and instinct has to be nurtured and developed to the point where the trained dog can be sent 100 or even a 150 yards to find a bird that it didn't even see come down. It then has to return to the handler negotiating fences, rivers and ditches and deliver the game undamaged to hand. To achieve that kind of success takes trust between the handler and dog, and months of dedicated training.

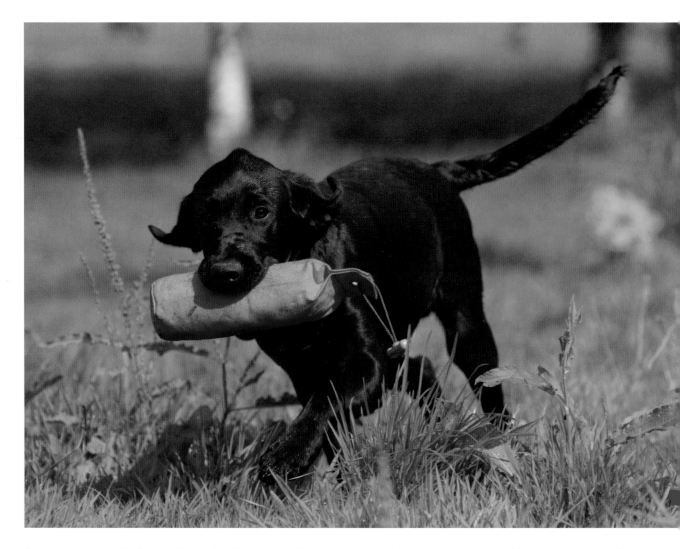

From an early age Labradors have a highly developed instinct to carry objects in their mouths. This pup is just starting his training.

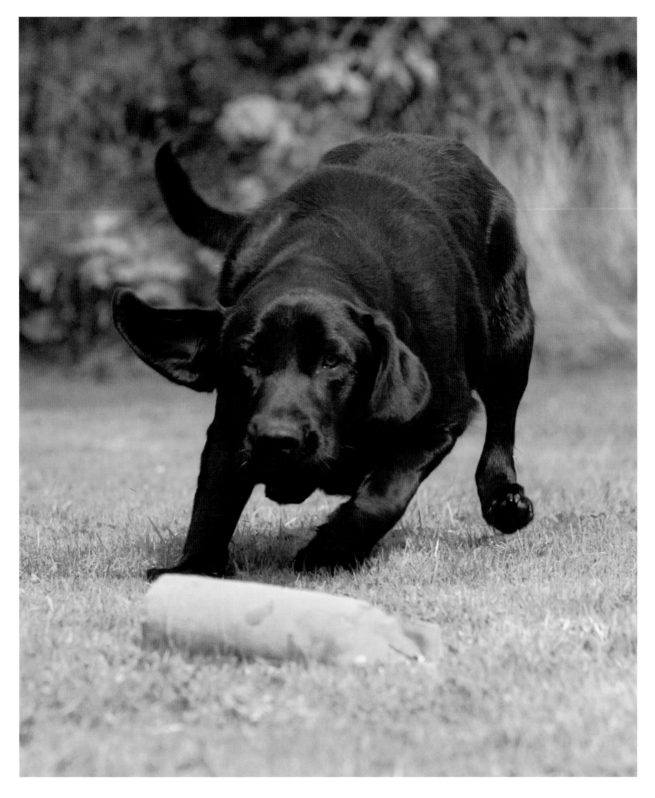

There is no doubting the determination of this young Labrador during a training session.

Whilst I have been photographing Labradors at work there have been many memorable moments but one in particular I remember quite clearly. Depending on where you live will depend on the kind of obstacles your dog has to negotiate, it may be a simple hedge, a fast flowing stream or a six-foot stone wall topped off with wire. I had travelled to the north of England to photograph some Labs on a training day and to be honest I had only really seen Labradors working on fairly flat terrain.

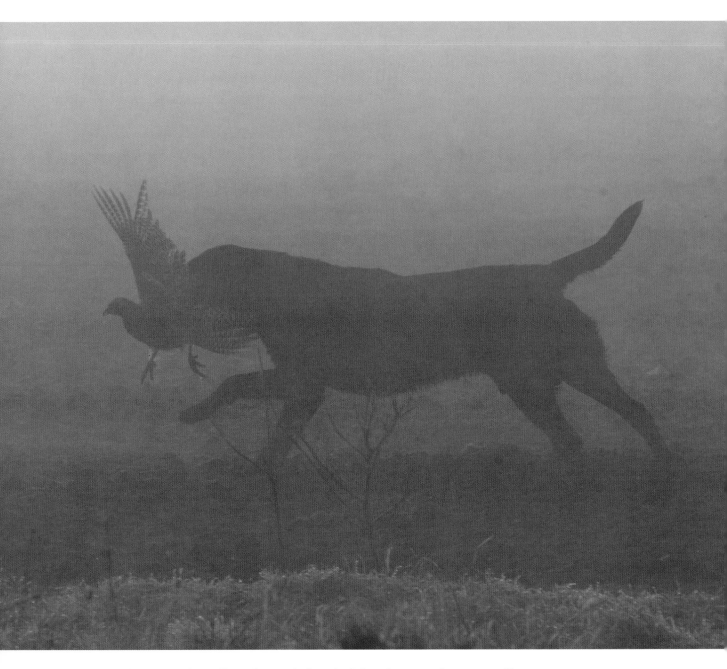

Labradors have to work in all weathers including thick fog where a good nose is vitally important.

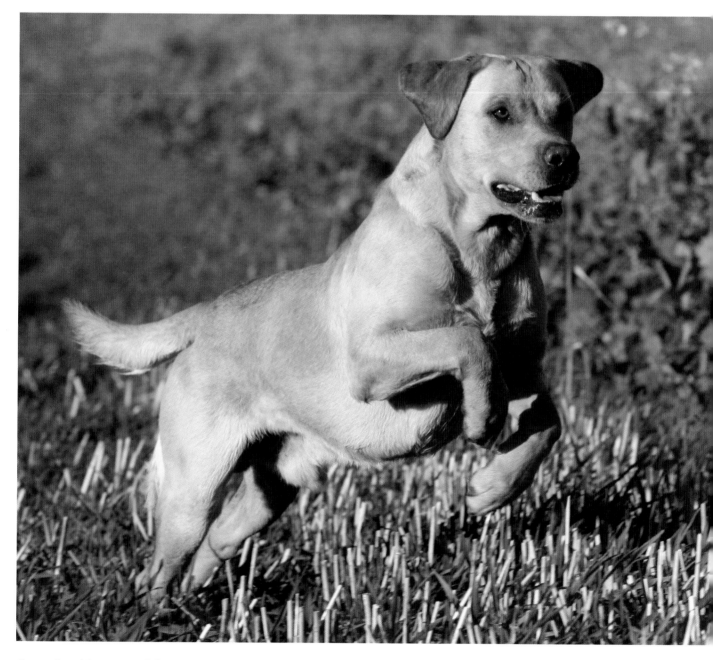

Strength, athleticism and determination — these are the characteristics of a working Labrador.

A rabbit was shot some 150 yards down hill (really that should be down mountain!) The handler had to send his dog for what was a totally blind retrieve. To digress for one moment, for those who aren't familiar with gundog work there are two kinds of retrieve. The first is a 'seen' which basically means the dog has seen where the bird, rabbit or retrieving dummy has landed. The second type is known as a 'blind' which means that the dog was unsighted from the retrieve and will have to rely on its nose and directions from the handler. Anyway back to the story, the handler sent his dog in the direction of the rabbit, however in between the dog and its retrieve were two six-foot stone walls each topped with wire. I was in awe as the dog scaled the walls and didn't even miss a stride. If I thought that was impressive the return was even better especially as the dog now had to negotiate a steep upward slope, the two walls and a dead rabbit.

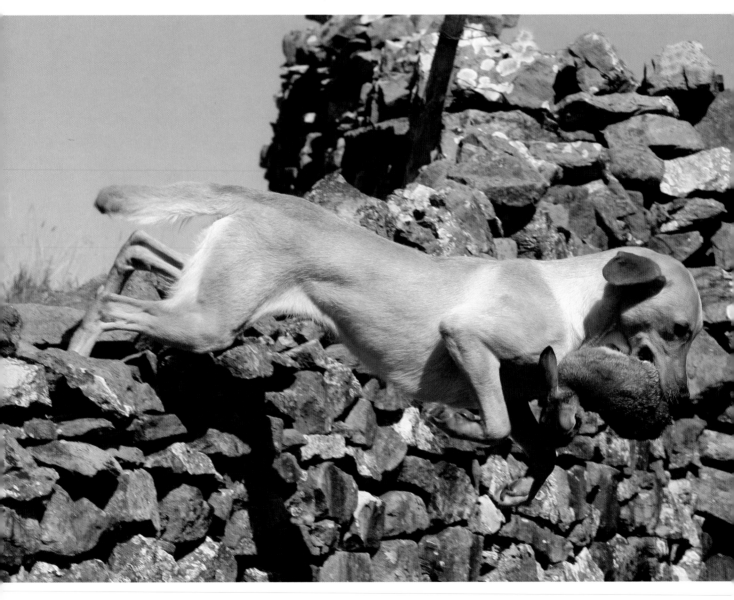

For a Labrador to tackle a high stone wall takes not only incredible strength but also a fearless courage.

Needless to say this was bread and butter to this Lab and as he delivered the retrieve to his handler I suddenly realised that I had been so engrossed in watching the dog work I had failed to take one photograph! Fortunately since that occasion I have been lucky enough to go back to the hills and have captured these wonderfully athletic dogs in action.

Any Labrador working in the shooting field will have to jump obstacles and most of them will tackle fences, streams and gates with ease. Most of my action images are taken 'as is' that is to say they are taken during either a working test or trial or indeed during a shoot day and therefore I have very little time to anticipate what is going to happen. However every now and again I do have the opportunity to set up a potential shot.

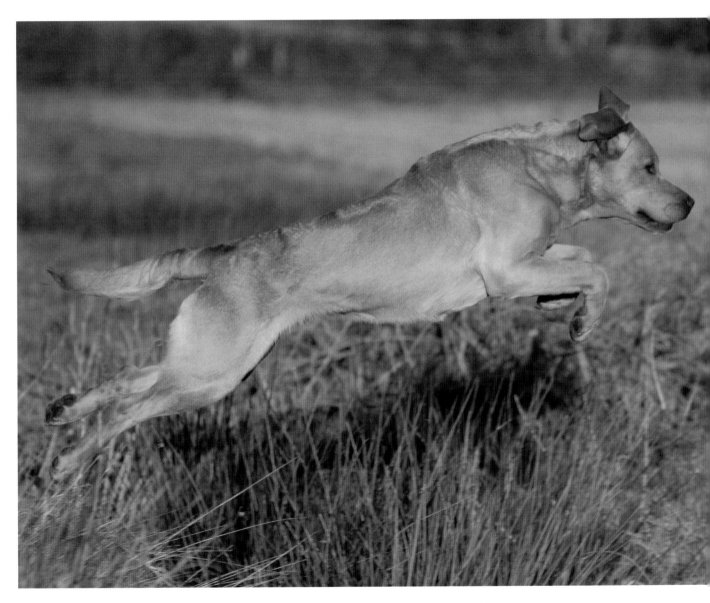

The Labrador is an athletic dog and is capable of jumping most obstacles found in the field.

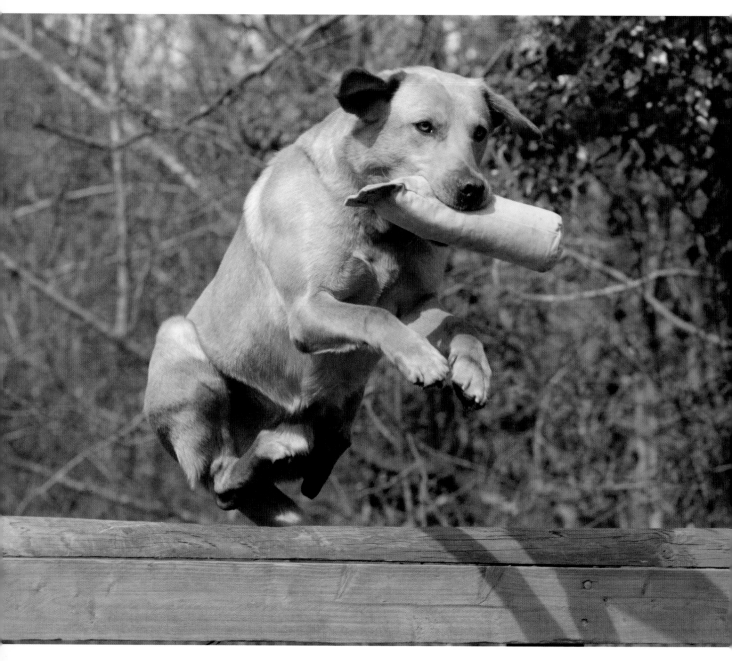

Fences are cleared with ease...

RIGHT: Sometimes it can even be amusing...

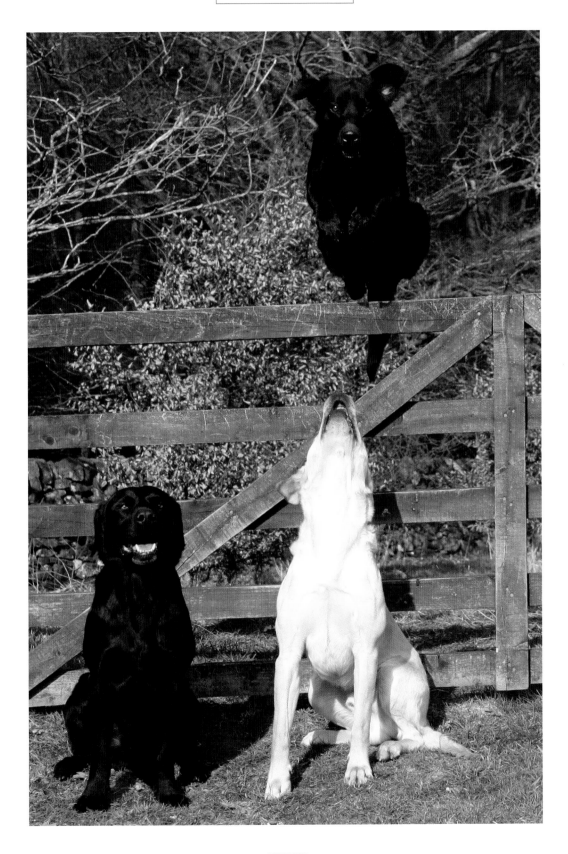

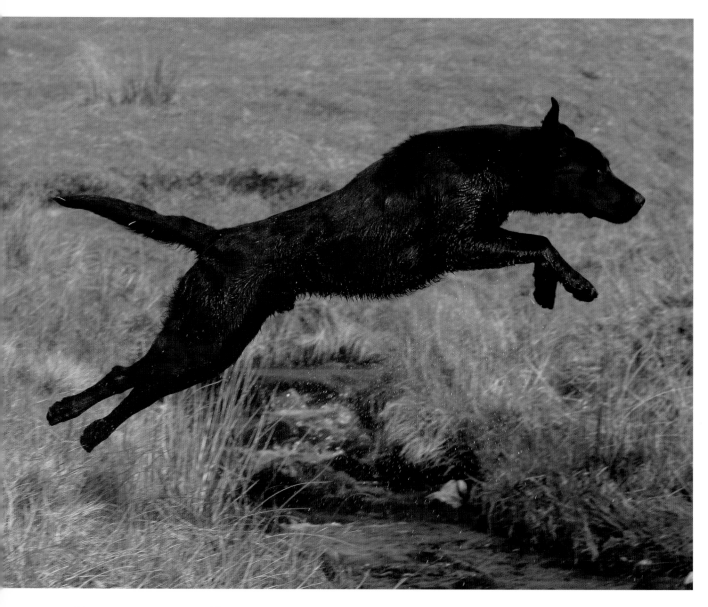

Even streams are not a problem...

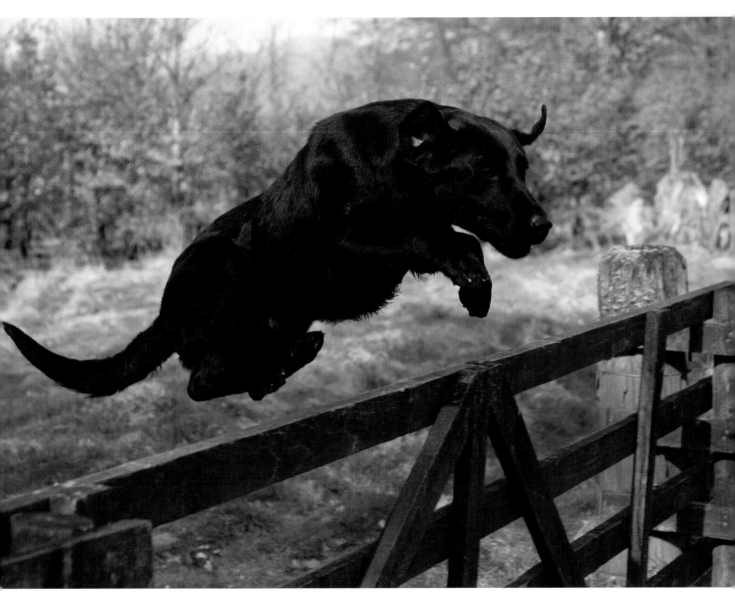

Gates are cleared with ease...

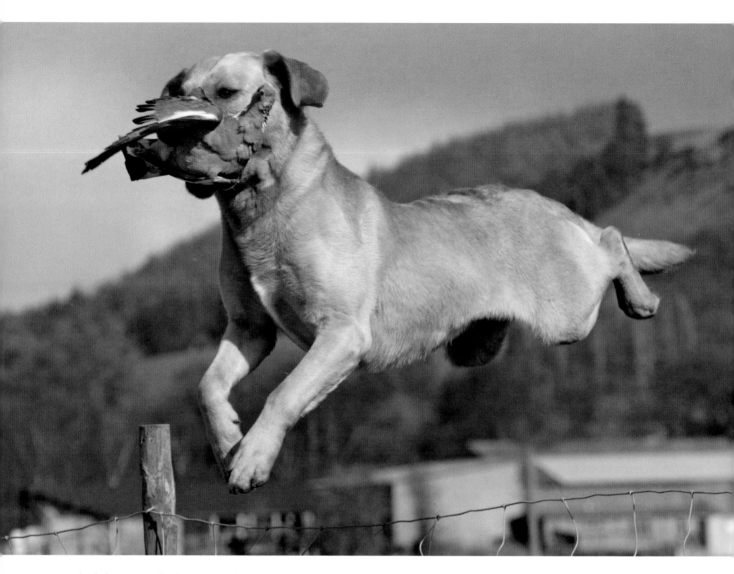

And there is no doubt a Labrador in full flight is nothing short of spectacular.

One of my favourites is an image that was taken in the Highlands of Scotland during a training session with a team of Labs. The dogs where practising jumping over a five bar gate when I thought it would be good fun to line up two of them on one side of the gate and to get another of the dogs to jump over the top of them. After a couple of failed attempts we changed the 'jumping' dog and that worked perfectly – it was then just a case of getting the angles right, what I didn't anticipate was the reaction of the yellow dog.

I take over thirty thousand dog images each year and every now and again you get one that stands out from all of the others, it may be a spectacular action image or it can simply be a portrait that captures a dog lost in its own thoughts. Jumping shots can quite often produce amazing high action pictures but they can also produce some of the most amusing. One in particular makes me smile every time I see it. This particular yellow Labrador had a jumping style all of its own and the first time I saw it tackle the fence I laughed so much that I forgot to take the picture.

Sometimes it can look painful…

When I focus on a dog in action I seem to be able to see everything in slow motion and I can see every feature of the dog, I am sure this ability has been developed simply through practice and perhaps a 'sixth sense' but in this instance I could see the dog's face as it jumped and the next time I made sure I took a deep breath and concentrated on getting the picture. Quite what thoughts were going through the dog's head I have no idea, on one hand it looks as though it is smiling but on the other hand it looks as though it has sat on something very sharp!

Sometimes I manage to take an image that is not only unique but has an element of luck attached to it…in more ways than one. I was photographing a working test with some of the best Labradors not only in the UK but also Europe, America and Canada. The dogs had to retrieve a dummy that had been thrown up a slight incline; to get to the retrieve the dogs had to jump two relatively low fences. Most of the dogs made a very easy job of the test and I was concentrating on getting shots as they jumped the fence. One black Labrador was very fast and made the outgoing run easily but as it returned it picked up a bit too much speed and tried to take the jump early. The dog clipped the fence and up-ended itself. I kept firing the shutter button and was relived to see the dog stand up, give itself a shake and carry on back to the handler. During all of its aerobatics it didn't drop or put the dummy down…a quite remarkable retrieve and a pretty impressive picture! The element of luck – well the dog was lucky it didn't hurt itself and I was lucky I got the photo.

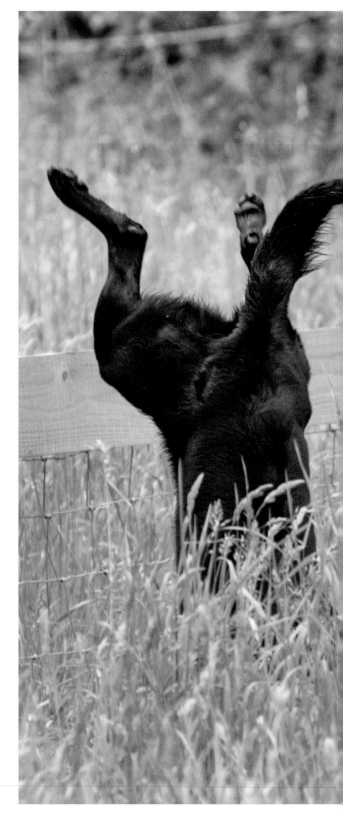

A pretty impressive jump and he didn't even drop the dummy!

Working Labs on the wide-open fields with very little in the way of landmarks can cause its own problems. Imagine a large flat field full of sugar beet or kale and when a bird falls there is very little for the dog or handler to use as a reference point. It takes skill, practice and a good nose to work this kind of landscape. For me it is perfect terrain, a good flat area which makes it far easier for me when tracking a running dog, it is even better when the crop is wet and there is plenty of spray to add to the atmosphere. It seems to me that the dogs also work in a different way when working these kind of fields, they seem to really power their way through the crops and will quite often be fully stretched on top of the plants which really shows their physique to the full. There is also something about the green in the way it contrasts with the colour of the dog regardless of whether it is black, yellow or indeed chocolate.

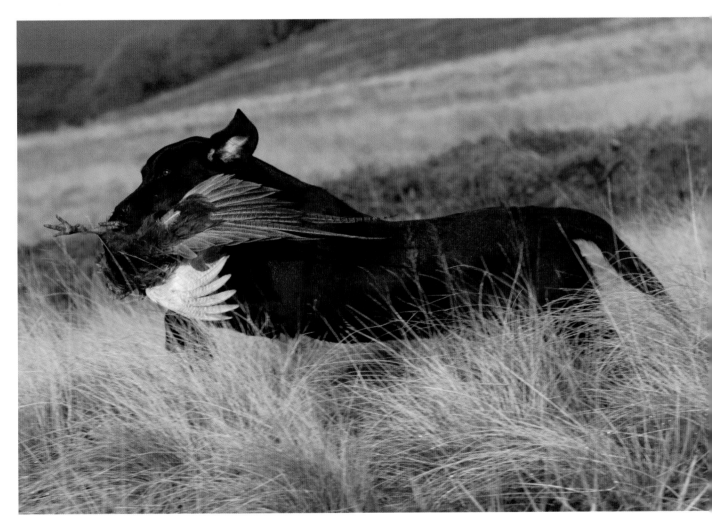

Taken in the Scottish Highlands this image shows a working black Labrador in all its glory.

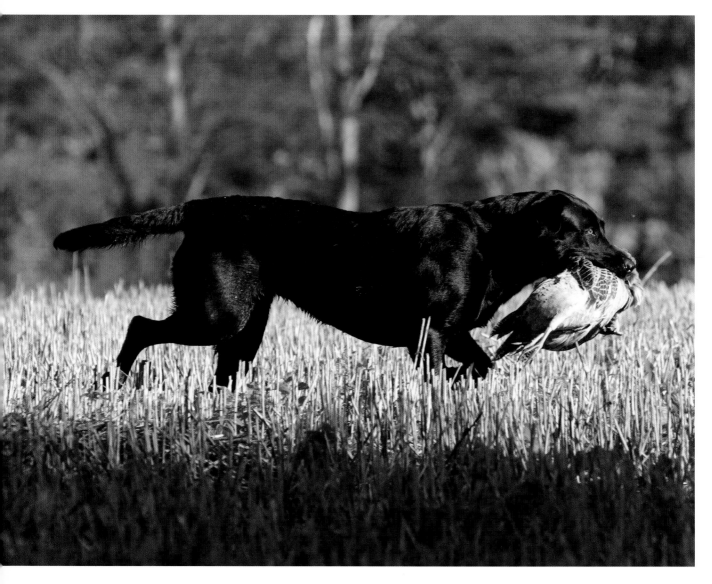

A Labrador working in a flat landscape will need good marking skills to locate his retrieve.

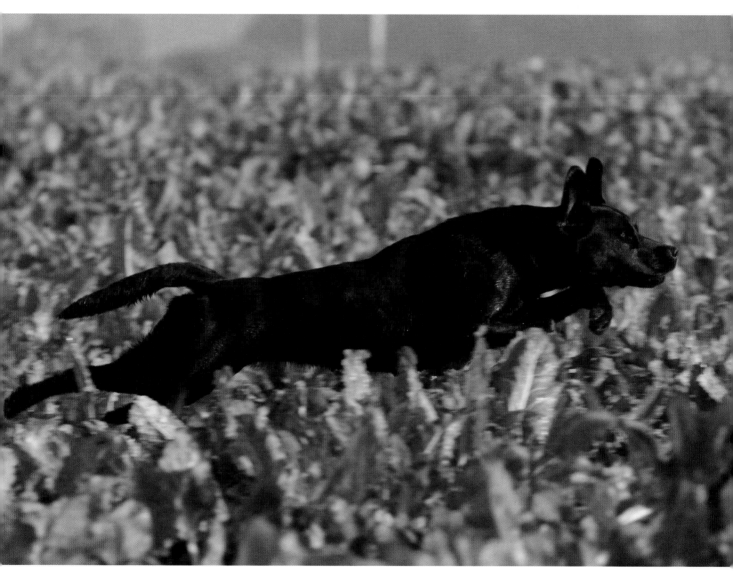

Sugar beet or kale makes the perfect backdrop when photographing a hard running Labrador.

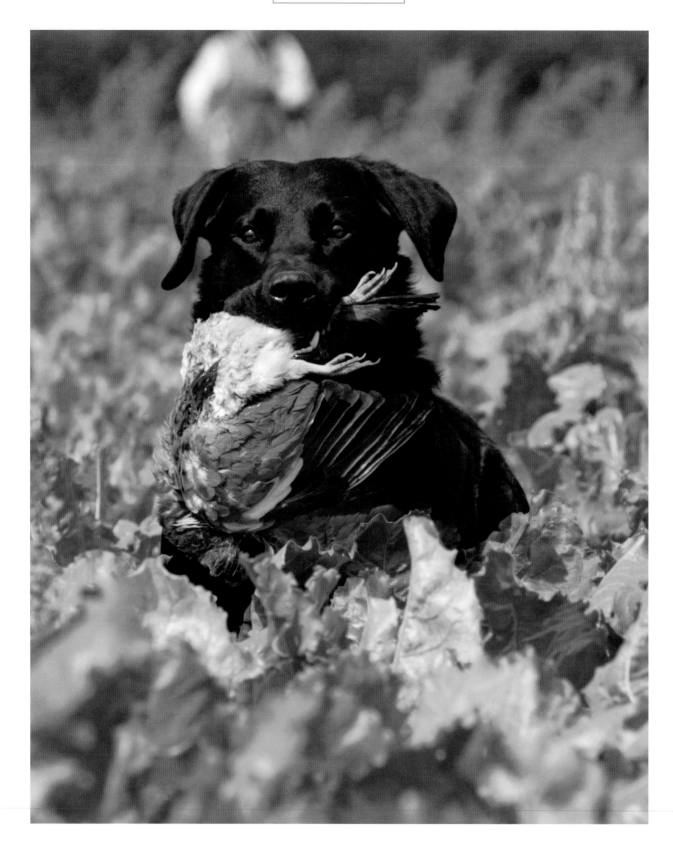

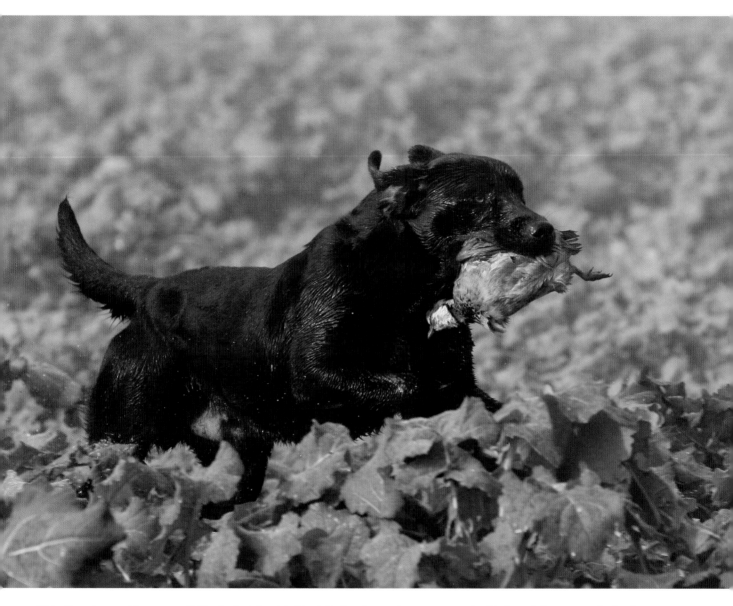

This French partridge was a difficult find for this black Labrador as the crop was quite high and there was a lack of scent.

LEFT: The crop in this field is difficult to penetrate so this Labrador will have used his highly developed sense of smell to locate the pigeon.

Chocolate Labradors

Mention chocolate Labradors to most gundog people and you will get a torrent of views ranging from 'Wouldn't have one of them they're all fat and lazy' to 'In forty years of shooting I have never seen a chocolate Lab work…you're having a laugh'. Well first of all let's take a logical look at this. The Labrador retriever has been with us in the UK since the early 1800s and were recognised by the Kennel Club in 1903. As we all know Labs come in three colours – black, yellow and of course chocolate – and over the years black became the dominant colour and in the early breeding programmes yellow and chocolate coloured puppies were often 'culled'. A few years ago there was a lot of press coverage in the UK on the attributes or indeed the lack of attributes of chocolate Labs working in the field and there were some pretty outrageous statements made.

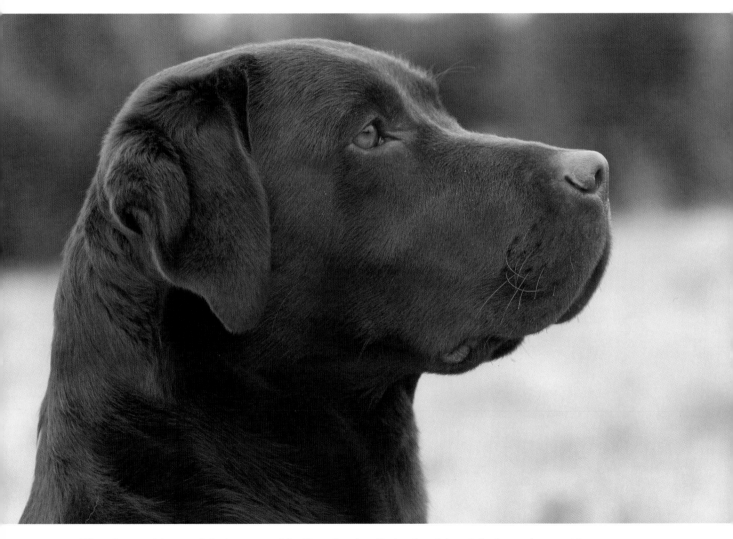

There is something special about a good-looking chocolate Labrador although looks aren't everything.

RIGHT: A chocolate Labrador dog poses for his photograph.

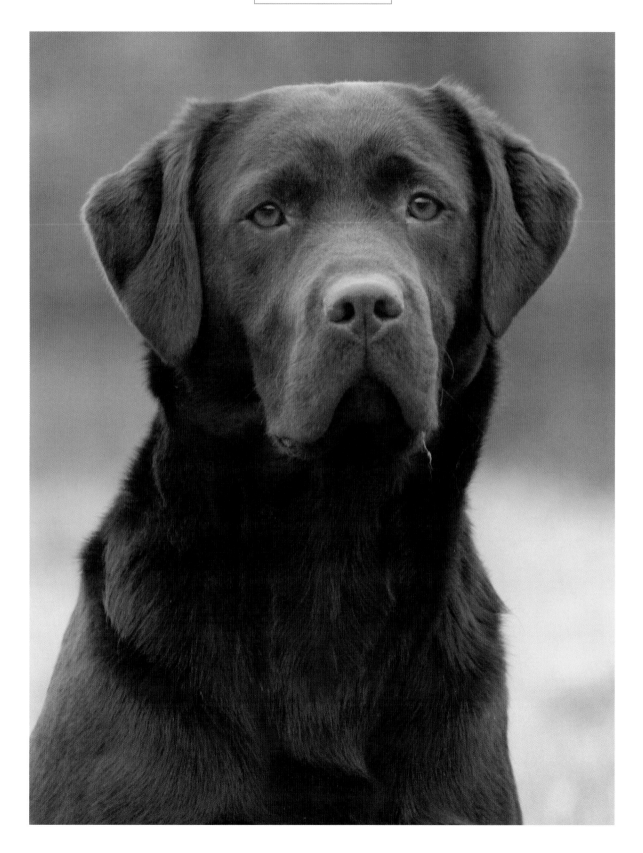

As well as running my dog photography business I am also Gundog Editor for a shooting magazine and rather than join in the mêlée I decided to arrange a day photographing a team of chocolate Labs picking up on a prestigious shooting estate and to find out first hand whether colour really did make a difference.

Chocolate Labs became popular in the show ring and today are particularly fashionable as 'pets' and to be fair in my day-to-day work of photographing all types of dogs, I do see a lot of over-weight chocolate coloured Labs. However, I learnt a long time ago that where working dogs are concerned you should never make generalisations.

The first thing that I noticed about these working dogs is that they really did not conform to the stereotypical view of chocolate Labs, these dogs were fit, athletic and went about their job with purpose. Ironically someone on the shoot mentioned that they were really black Labs in brown coats! As the day progressed I soon forgot I was watching what many people view as a sub-standard coloured gundog, but then what is in a colour anyway? I personally don't like spaniels that have a lot of white on them, but this doesn't affect their work and is simply a matter of choice and what is pleasing to the eye. These dogs were certainly pleasing to my eye.

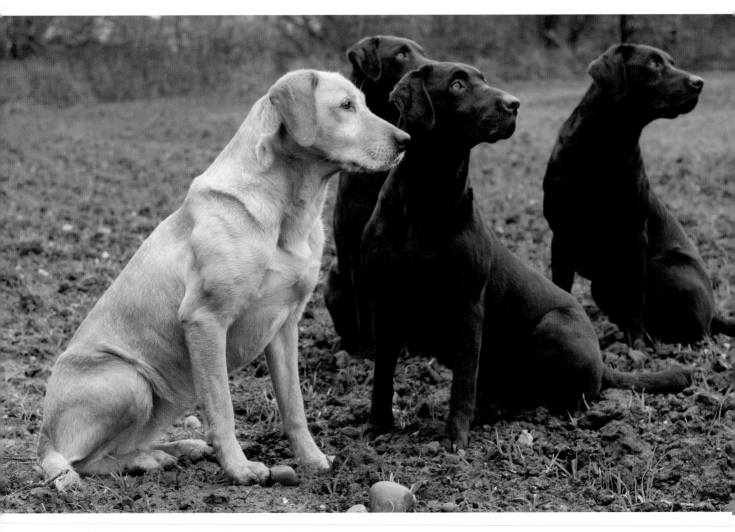

This picking-up team have their eyes on the job.

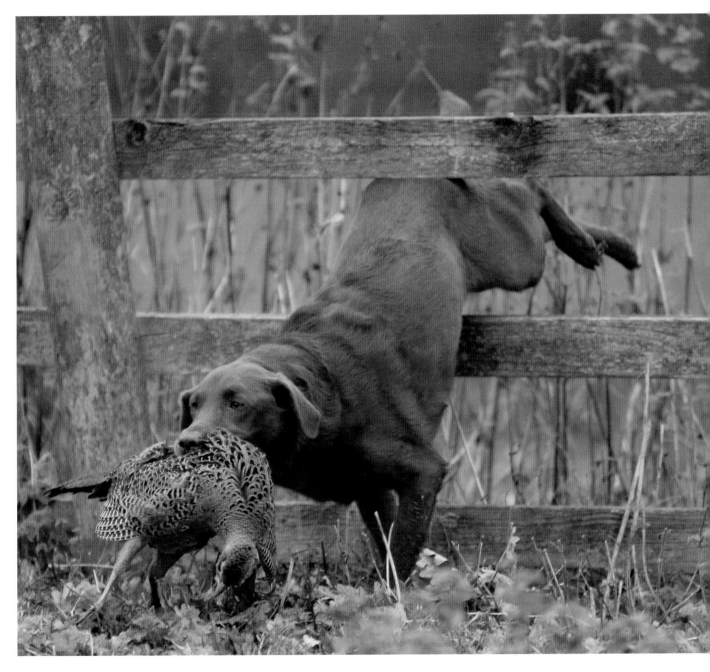

There is nothing fat and lazy about this working chocolate Labrador.

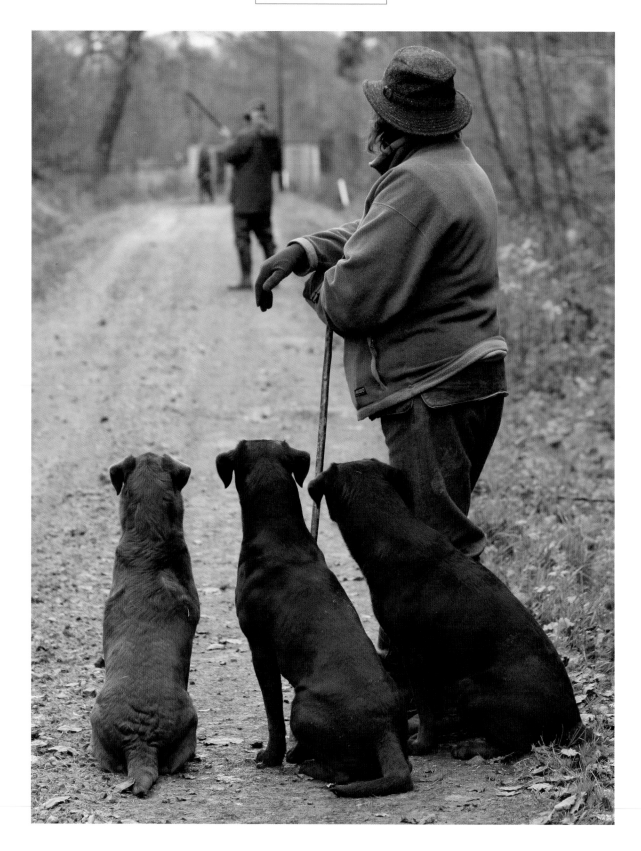

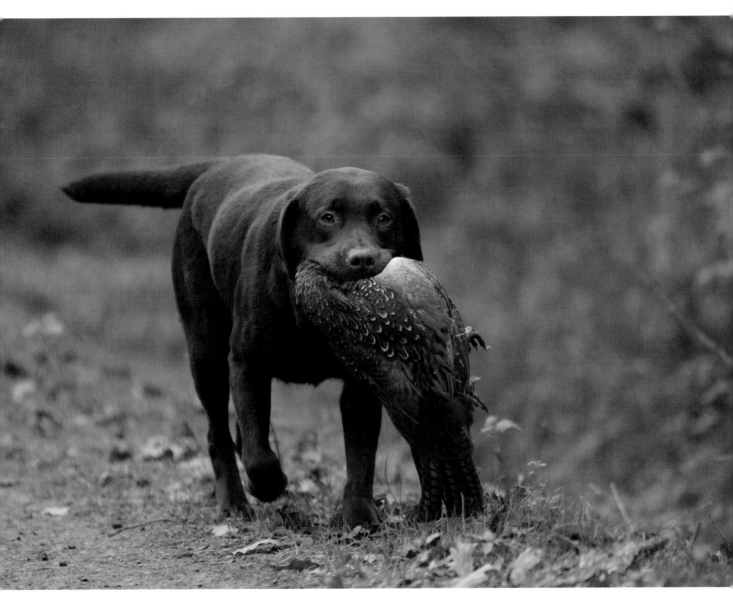

A traditional looking chocolate Labrador with a strong frame and a classic 'otter' tail.

LEFT: A chocolate Lab can come in various shades of brown...

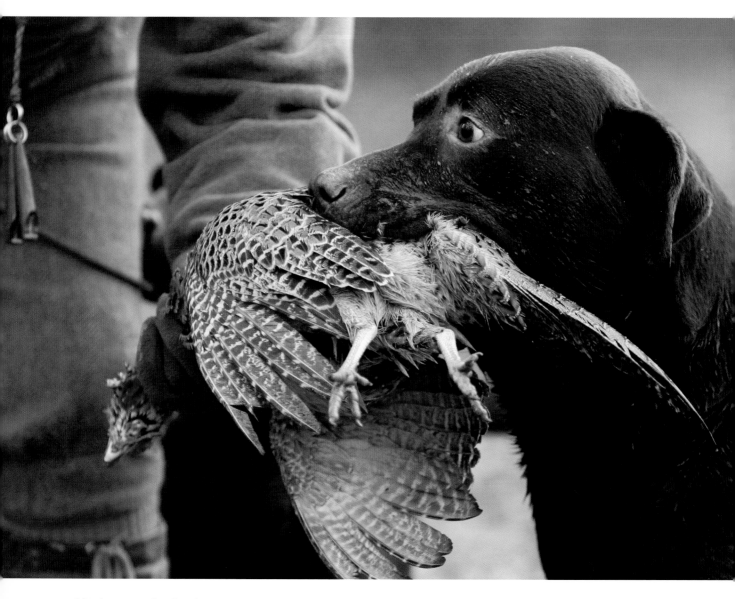

Nicely retrieved to hand...

Black and tans

Not so long ago I received a telephone call and the chap at the other end of the phone sounded rather excited. He told me that he had two very special Labrador puppies and he thought I would be interested in taking some photographs of them. As he was a good couple of hours away I wanted to know what made these dogs so different. He went onto tell me that these two puppies were black and tan in colour and that was very rare. I tactfully asked him if he was sure they were pure Lab and that a Rottweiler or Doberman hadn't managed to get to the bitch. He went on to explain that he had just spent a considerable amount of money having the pups and the parents DNA tested and all of the tests proved that they were pure Labs and as a result the UK Kennel Club have now registered them, although they have been classed as being black as they have more than 80 per cent black colouring.

Not your usual coloured Labrador puppy…

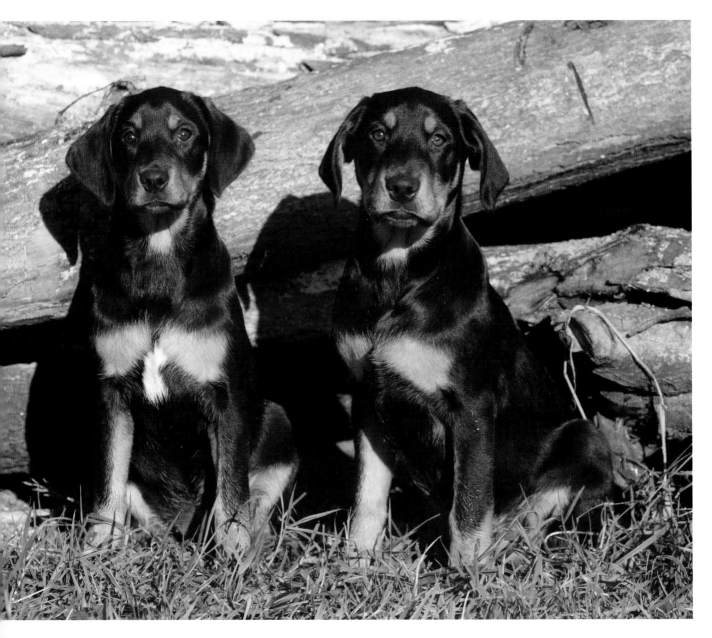

Two quite rare black and tan marked puppies.

I did some research on the Internet as I had never heard of such colourings and I found out that the black and tan colouring is due to a modifier gene normally present in Labrador retrievers. It is recessive and therefore requires each parent to contribute the black and tan gene to an individual for the colour to show up. It can modify a black or chocolate Lab to have lighter tan markings in the usual locations of a Gordon Setter, Doberman or Rottweiler. Although this variation of colour is classed as 'miss-marked' and the dogs will not be able to be shown it shouldn't make any difference to the working ability of the dogs.

Despite the unusual colouration, the natural retrieving instincts are already highly developed in this fifteen-week-old black and tan pup.

Peg dogs

I sometimes think that being a peg dog must be the most boring job a gundog can perform. To sit absolutely stock still next to your owner watching bird after bird fly overhead and then be sent for what in truth are pretty easy retrieves hardly taxes the body and soul, but the Labrador has taken this job in its stride.

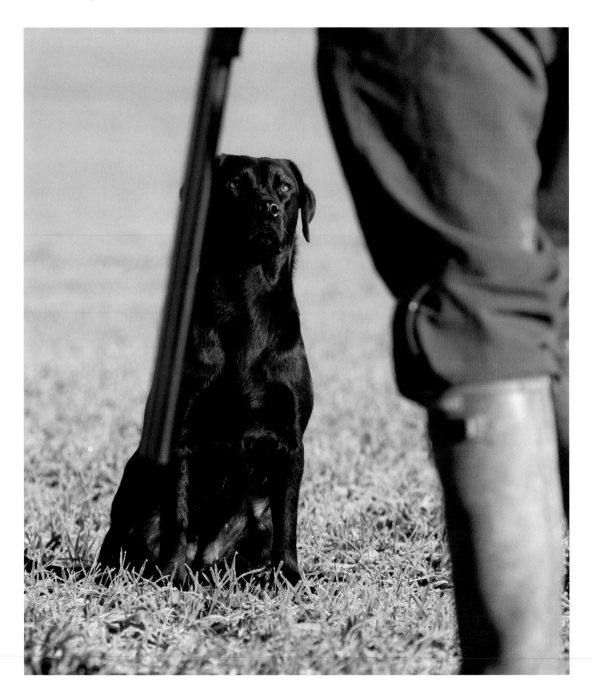

Being a peg dog takes self-control and plenty of training.

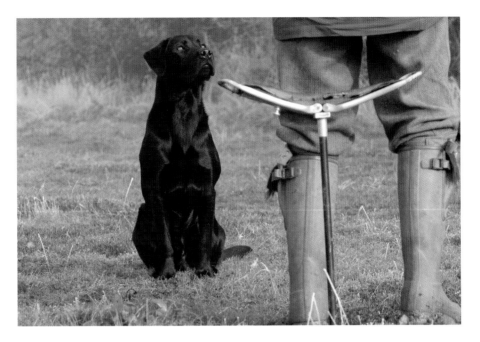

Steadiness and concentration are the key skills for any peg dog.

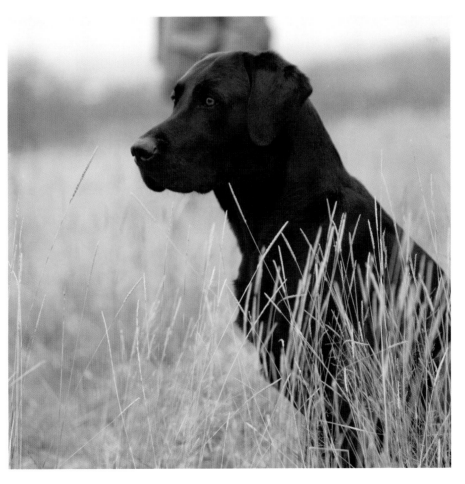

LEFT: *Being a peg dog is second nature to the Labrador and this dog is totally focused on his owner.*

When you think about it every natural instinct of the dog has to be channelled into self-control. It must be steady to birds falling all around it, it may have to be sent for a running bird and ignore all of the dead ones on its outrun, it must not make a sound as squeaking in the field is a cardinal sin and will draw disapproving looks from the other Guns.

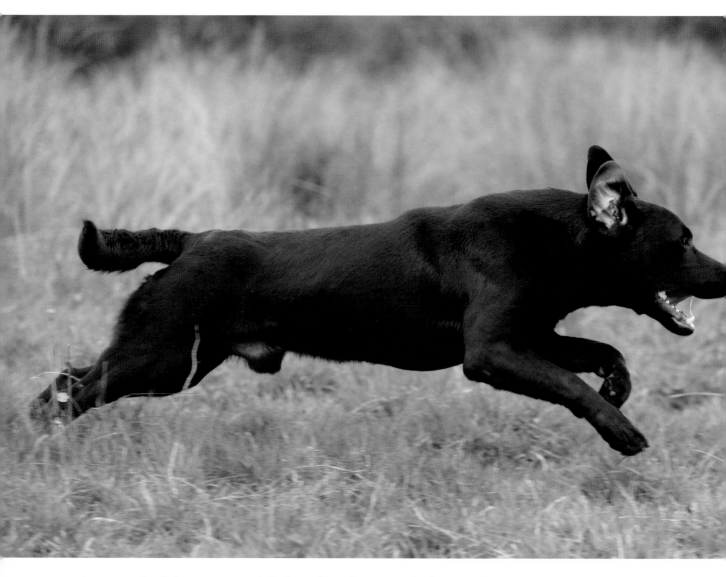

A strong and stylish run out not only looks good but also ensures the dog gets to his retrieve quickly and efficiently.

RIGHT: A yellow Labrador waits patiently for his Gun to return to his peg.

I always imagine a peg dog to be the landed gentry of the gundog world and you could imagine them looking down their snouts at the spaniels and referring to them as riff-raff! In truth they do play an important role in the shooting field and the way they focus on their handler waiting for the command to 'get on' is a joy to photograph.

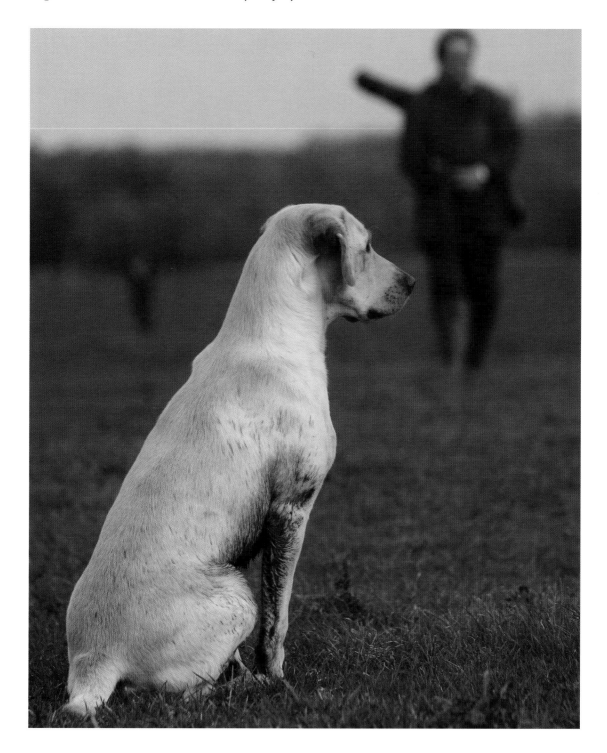

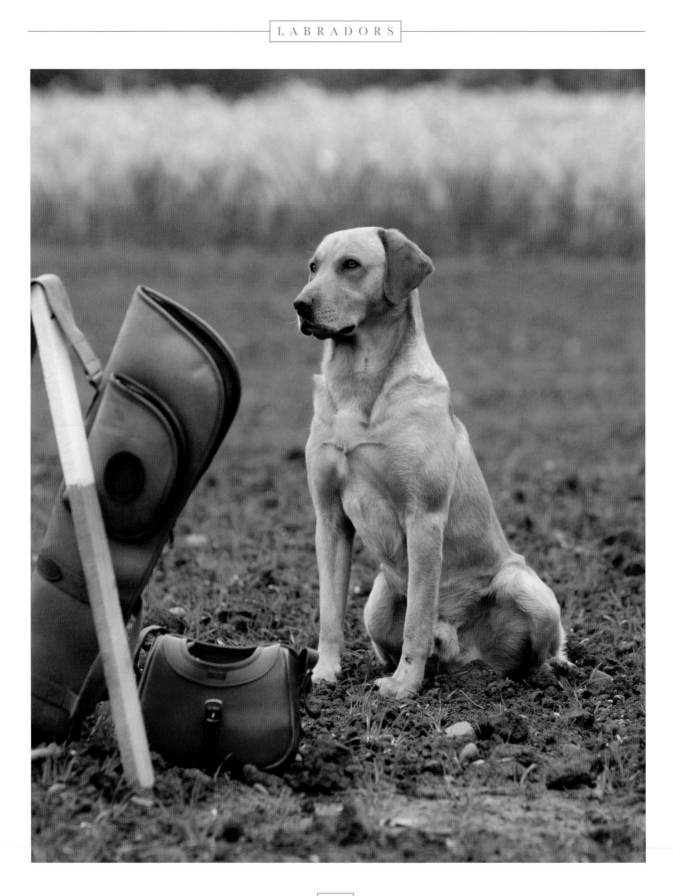

Wildfowlers' Labs

If the peg dog is the landed gentry of the dog world then the wildfowlers' Labrador is the canine equivalent of the Special Forces. Make no bones about it these dogs are tough and very brave and they work in some of the most inhospitable conditions of any dog. A few years ago I took a trip out to the east coast to accompany a well-known wildfowler and his yellow Lab. The dog looked as though it had seen some hard work with a large scar running down the side of his head but over the next ten hours my admiration for this dog grew and grew.

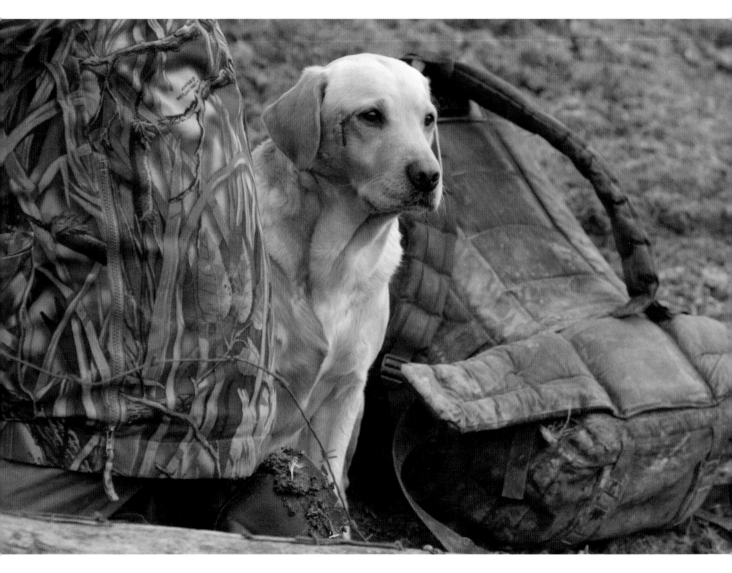

This wildfowler's dog takes shelter behind his owner as they wait for the evening flight. The large scar running down the side of his face is testament to the dangers of his job.

LEFT: A classic shot of a peg dog at work.

The weather was bitterly cold and there was plenty of sleet and snow in the air, and the dog took full advantage of the shelter his handler gave from the driving wind. During the long hours of inaction the dog didn't move which was vital, as the slightest movement would have spooked the flighting wildfowl. As the day drew on a teal was shot and the dog sprung into action, he negotiated a tidal mudflat and found the bird and made the retrieve all without any command from the owner. I was used to handlers using whistles and hand signals to direct the dog but as dusk fell I realised that this kind of handling would be pointless as in the dying light the dog wouldn't be able to see his owner and the dog had to depend on his own instincts and strength.

With hours of inactivity and bitingly cold winds the dog had to stay perfectly still to avoid spooking the incoming wildfowl.

Despite being cold and wet the dog didn't hesitate in crossing the mudflats to retrieve the duck.

The dog had returned to the bankside covered in mud and soaking wet, but he simply curled up and waited for the next piece of action, which came just as the sun dropped below the horizon. The tide had started to come in and the channel on which we were hoping to catch the evening flight of duck was beginning to flood. This time a widgeon was shot and in the darkness the Labrador leapt into the icy water. There was quite a flow in the channel and in the gloom I could just make out the dog trying to make for the far side of the bank where he instinctively knew the dead bird would be. After about fifteen minutes a very wet and cold but triumphant Labrador climbed up the bank with his retrieve. That was an incredible piece of dog work and it is no wonder a wildfowling dog has a shorter working life than its landlocked cousins.

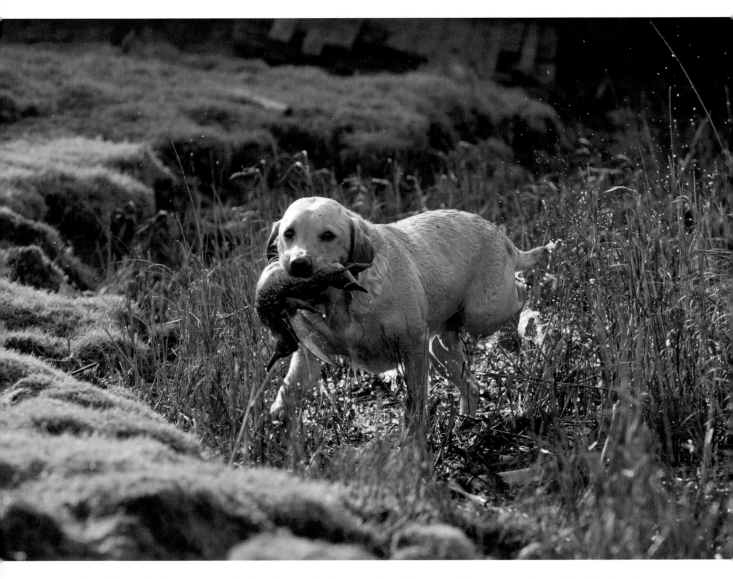

A wildfowler's dog needs to be independent and able to work on his own without any guidance from his handler.

RIGHT: Not all ducks are shot on the foreshore; this black Labrador retrieves a mallard during a driven duck shoot.

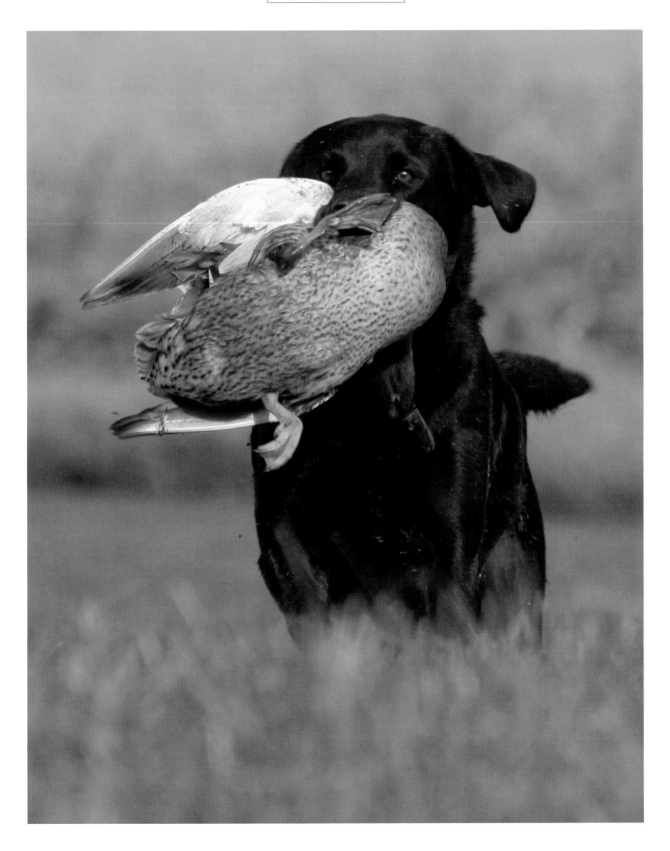

The shooting season

The shooting season in the UK starts on 12 August, 'The Glorious Twelfth' and for many Labradors this is when the real work starts. A grouse moor at the beginning of August can be a hard place for a gundog to ply his trade. The weather can be very warm which doesn't help scenting conditions and there is little or no water around for a hot dog to quench its thirst. Heather can be really hard going especially early in the season when the dogs are just coming out of a summer of rest, coupled with an incredible amount of pollen that just seems to follow the dogs as they hunt for a fallen bird. Include a few million midges and I could see a few requests to transfer to the mud flats!

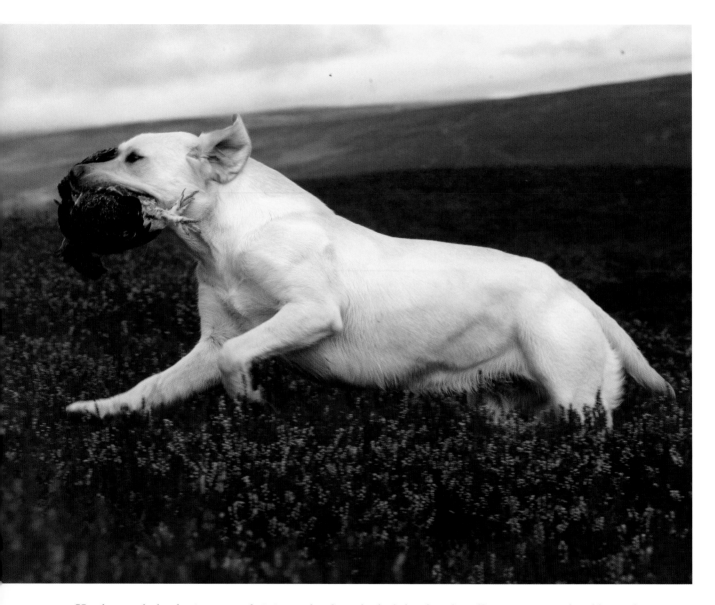

Heather can be hard going, not only is it very harsh on the dog's legs but the pollen can cause real problems when trying to locate fallen grouse.

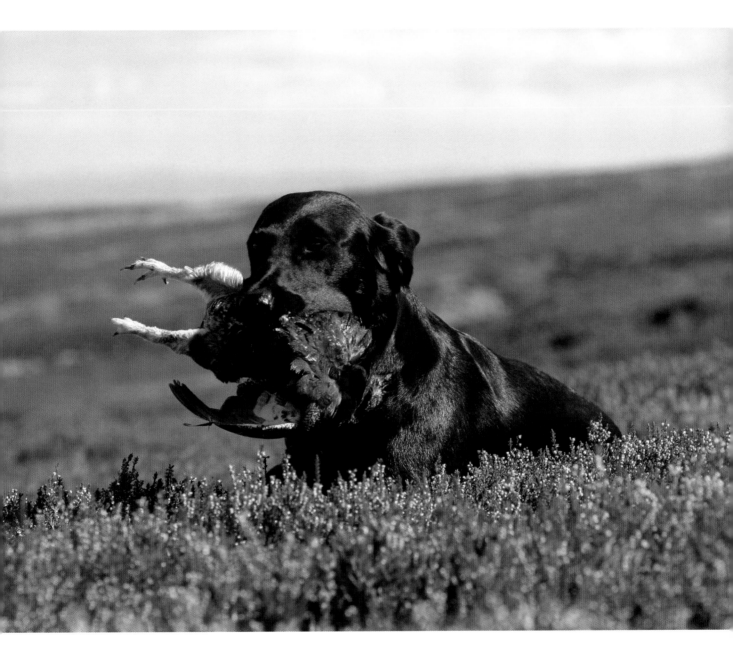

The heather can be quite thick in places but what a perfect location to photograph Labradors at work.

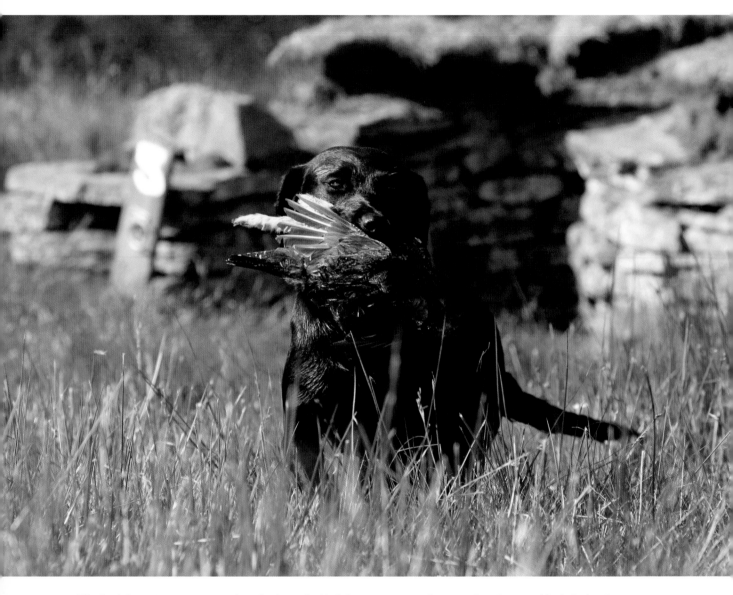

The backdrop of a stone grouse butt high on the Yorkshire moors complements this shot of a black Labrador retrieving a freshly shot grouse.

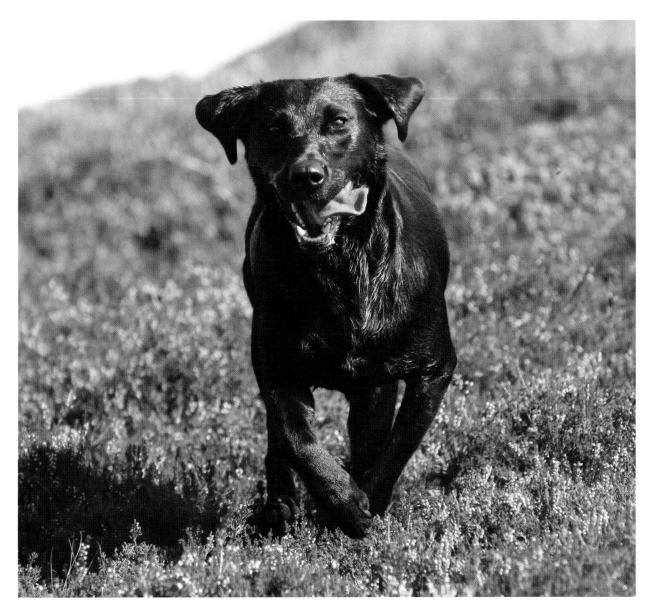

It can be hot work in August on the moors.

Like many forms of gundog work there are periods of inactivity and then periods of intense work and the Labs on the moors have learnt to use the down time to their advantage. At times I think it must be great to be a Labrador, one minute you are alert to every movement and smell and the next you find a comfortable hollow and nestle down for a quick doze...it really is a dog's life!

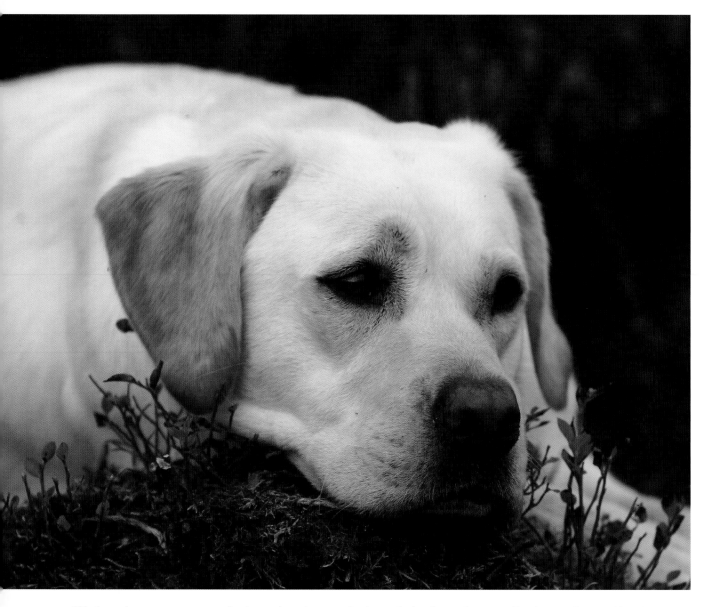

Work on the grouse moors can be demanding for even the fittest Labrador and most will take a well earned break between drives.

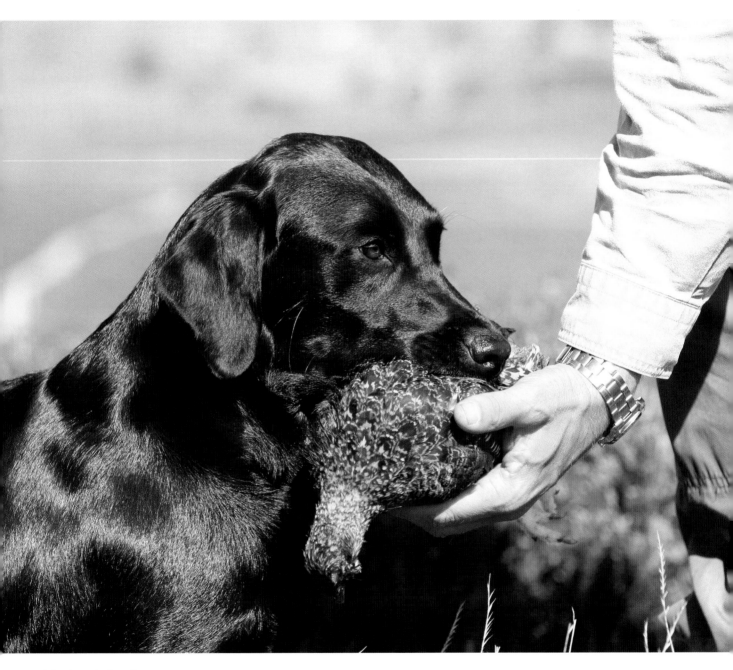

A bird in the hand...

There is one element that the Labrador retriever really excels in and that is in the water. Ideally the breed should have a double coat and many of the dogs that have the old fashioned blood lines in their ancestry will have a good thick 'otter' tail that works as a rudder when the dog is swimming. They also have semi-webbed feet and from an early age they take naturally to the water. As a dog photographer the most stunning image I can take is of a dog either leaping or powering its way into a lake or river.

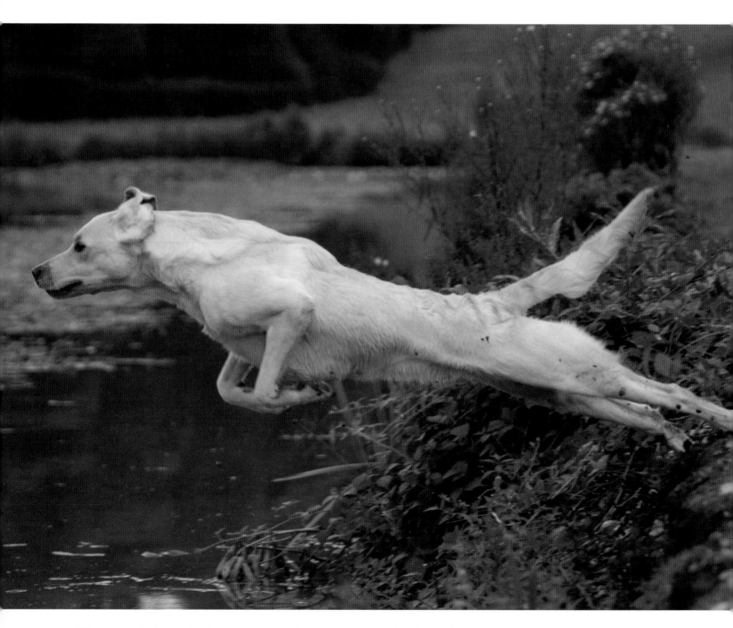

There is no doubting the determination and courage of this Labrador as she leaps into the lake after her retrieve.

RIGHT: The Labrador was born to work in water and this powerful black dog is totally focused on his job.

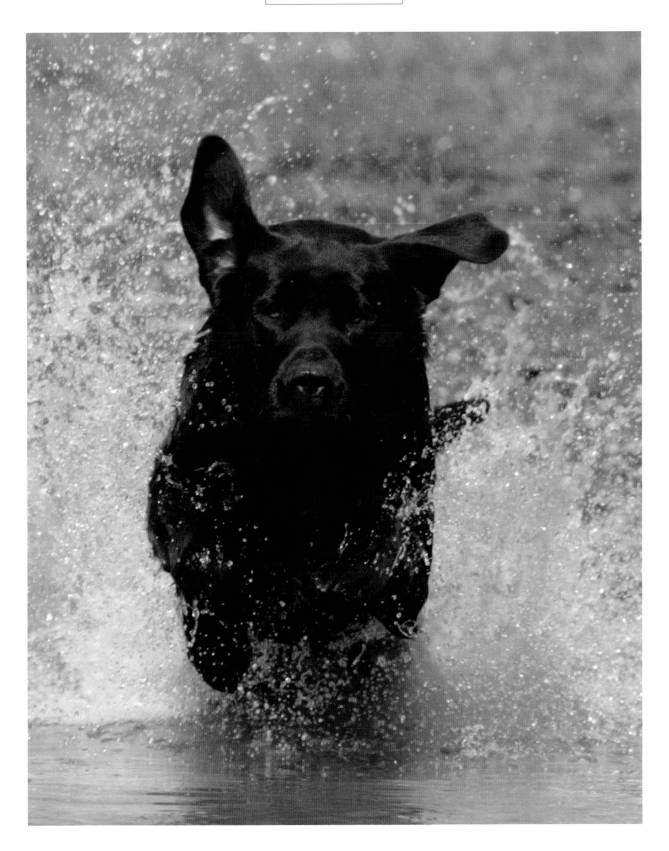

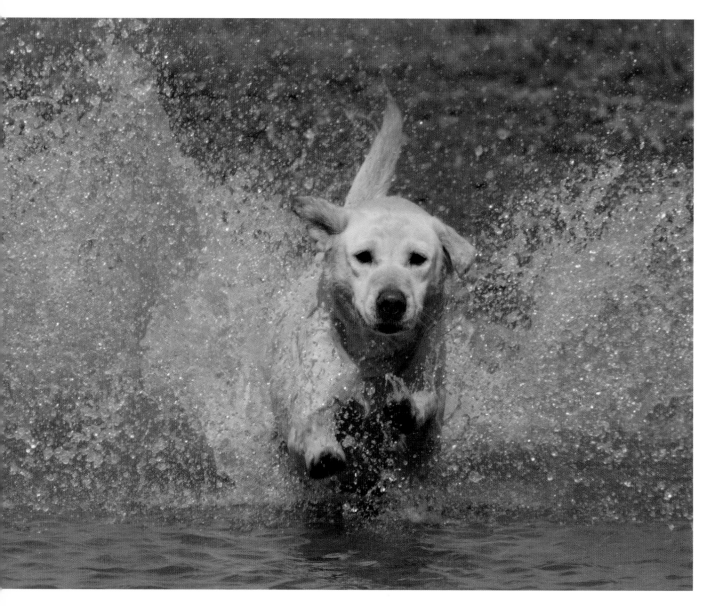

Even elderly Labradors love water...

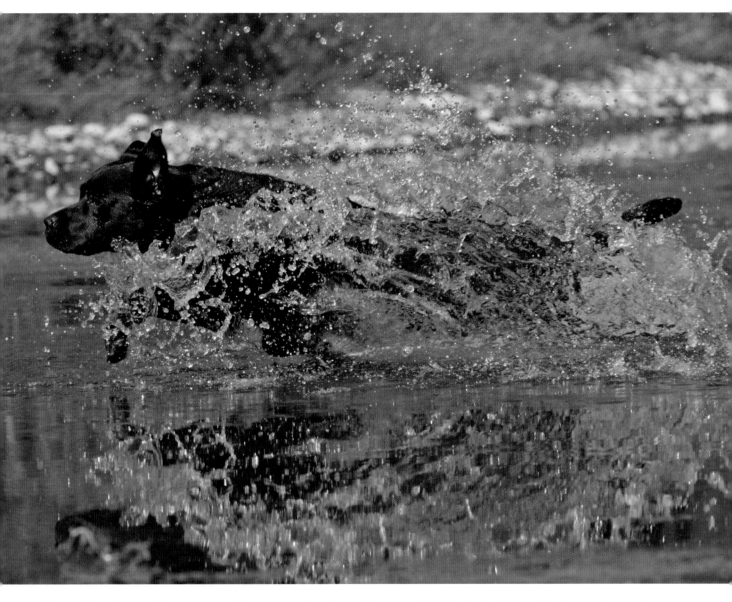

Now and again everything comes together...water, reflections and a strong black Labrador doing what he was born to do.

Over the years I have developed various methods and techniques to enable me to get that extra special image including wading out into the water wearing chest waders so I can get a perfect dog's eye view.

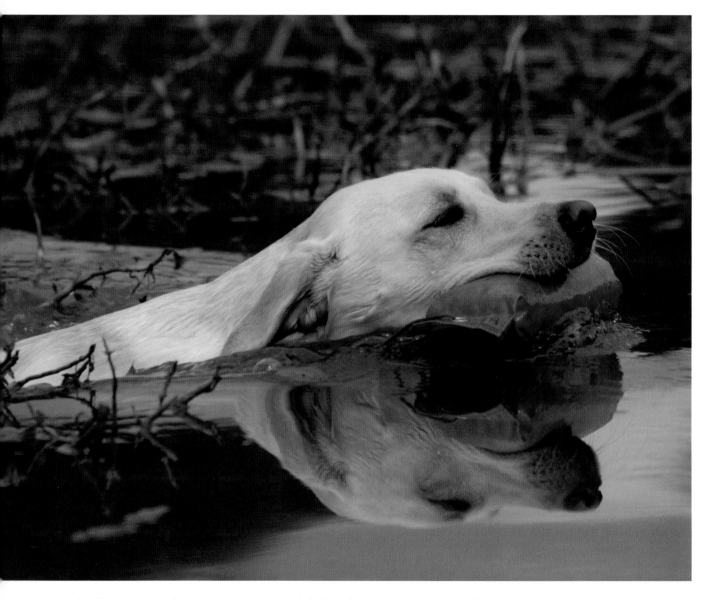

I will go to any ends to get the perfect shot including donning chest waders so I can get a dog's eye view.

Although a spectacular leap is impressive to watch I do sometimes cringe when I think what obstacles may be under the water and what damage could be done to a dog, fortunately in all my years of photographing these dogs I have never seen one injured as a result of a flying leap.

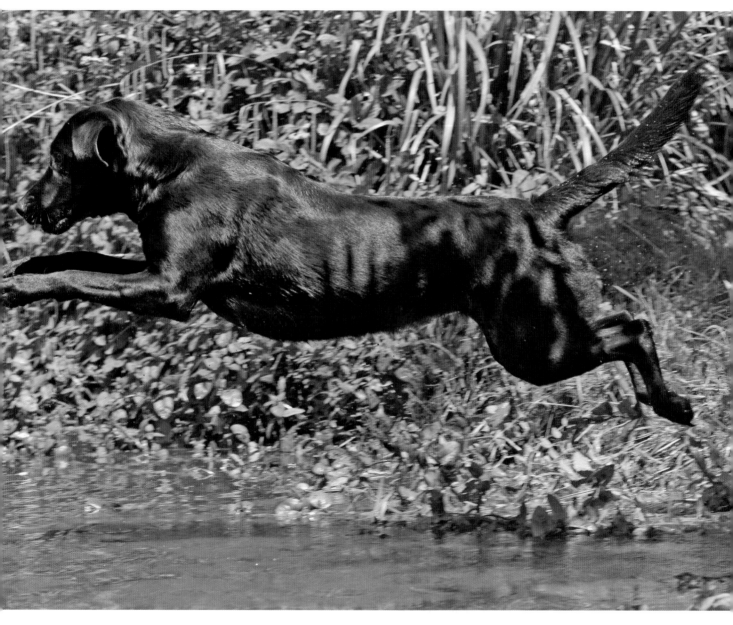

A leap into the unknown...

Water

One aspect of photographing Labradors in water that I really do enjoy is trying to capture perfect reflections of the dog in the water. The conditions have to be right but when everything comes together the results can be quite dramatic.

Ideally the day should be windless so the water is flat and it works best if the vegetation is quite close to the bank so it is reflected in the water and this gives a dark backdrop, which helps to contrast with the dog; the photograph will also work if the sky is bright blue. In fact not so long ago I was photographing a fox-red Labrador during a duck shoot and it was a bright winter's day and a female mallard had just been shot and the dog was making its retrieve. The conditions were perfect and the resulting picture epitomises the Labrador's original role as a waterborne retriever.

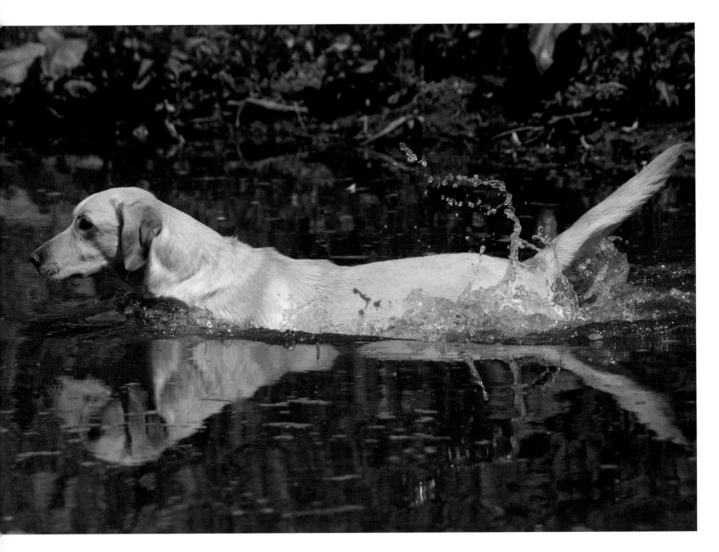

One of my favourite water shots. The flat water and the dark vegetation help the near perfect reflection.

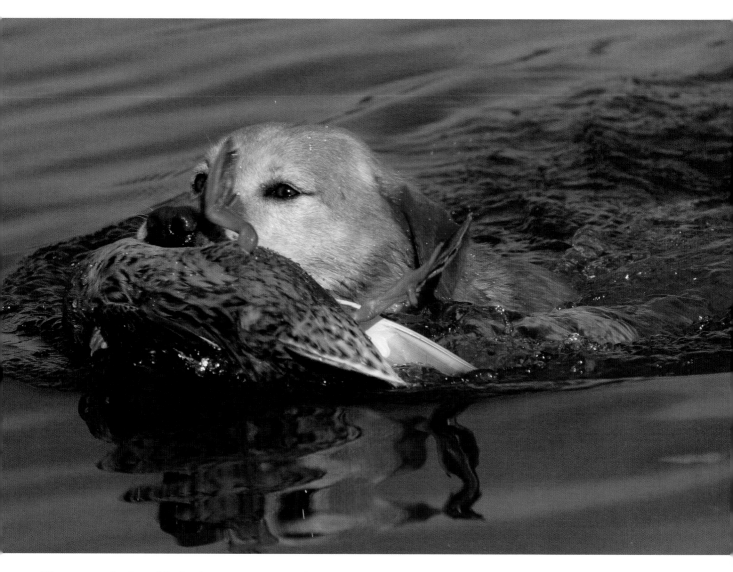

This image of a fox-red Labrador retrieving a female mallard epitomises the dog's original role as a waterborne retriever.

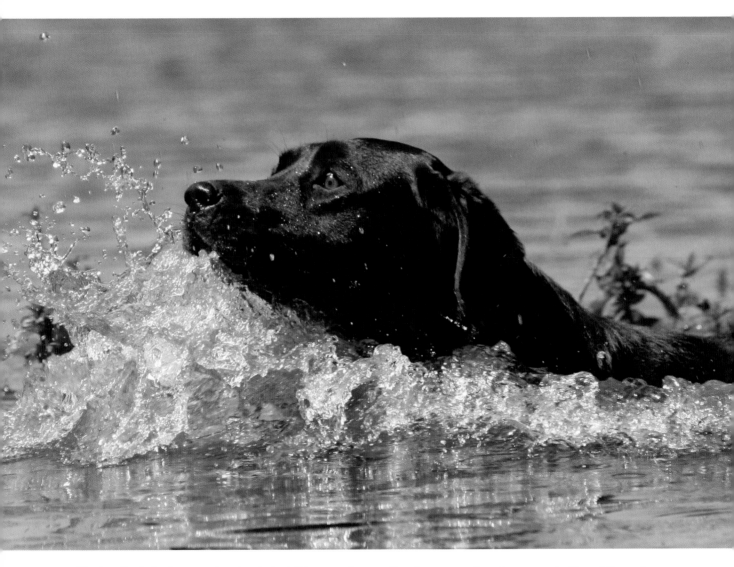

No this black dog is not swimming in ice! I have used a very fast shutter speed on the camera to 'freeze' the water splashes.

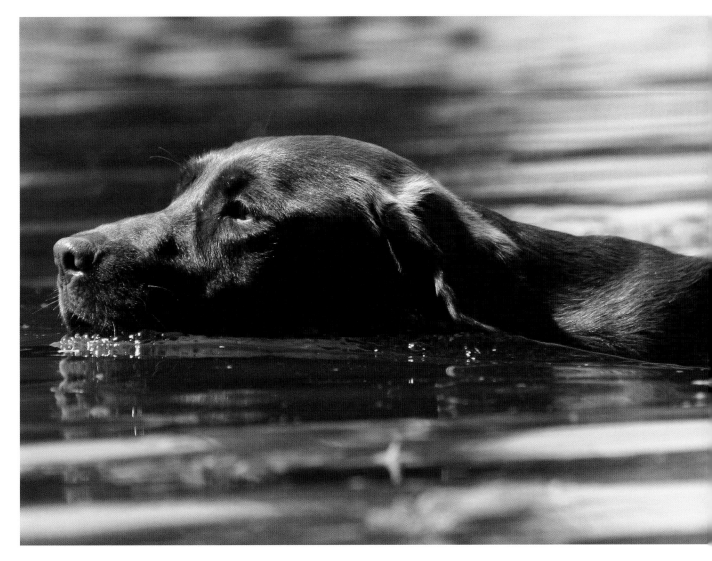

Holding a very expensive camera when up to your chest in water is a bit scary but the results are always worth it.

Every year during the summer months many gundog clubs have 'water picnics', which consist of a number of retrieving tests that not surprisingly revolve around water and I always try to attend a few of these each year. My particular favourite is held on a small estate where the location is about as perfect as can be to take photographs. The key to this setting is not in fact the water but a small rocky island that is in the middle of the lake. As the dogs are sent over the water they nearly always come out onto the island and look back towards the handler for further directions, it is that moment that makes the image. The dogs are totally focused and their bodies are tensed ready to move on the next command. That coupled with the water that is falling off their coats and the surrounding scenery makes for quite a special picture. If I am lucky the dogs find the dummy and leap back off the island into the water so in fact I get three water elements, swimming, leaping and the water flow....

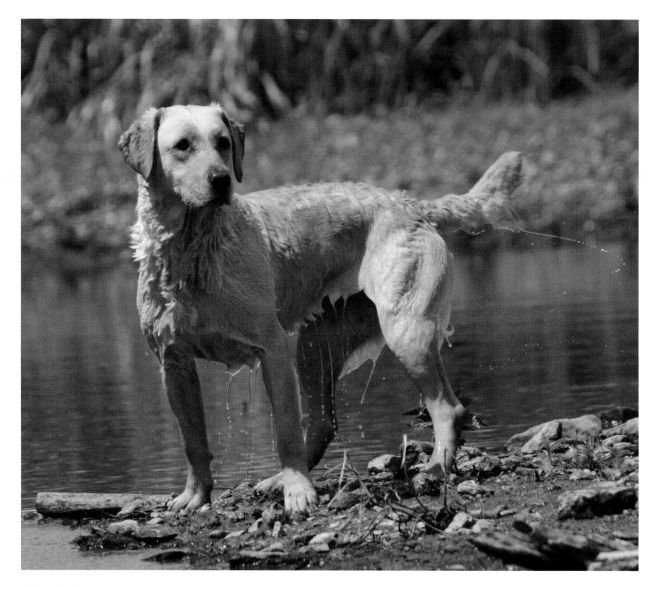

Labrador 'water picnics' are great to photograph and my favourite is held every year on a small estate lake. There is a small island on which the dogs quite often give me the perfect opportunity to capture the moment.

People quite often ask me if I have a favourite image and I have to say that changes on a fairly regular basis, but I do have a favourite *type* of image and that is just as a dog leaves the water. I love the way the water falls away from the fur especially on a dog like the Labrador which has an oily water-proof coat.

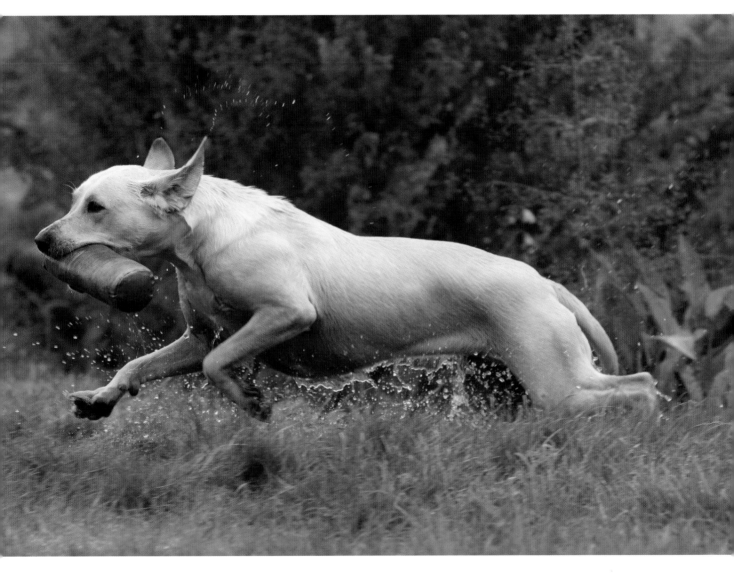

My favourite type of image is just as the dog leaves the water and races back to its handler.

The next stage is when the dog shakes and you get ears and jowls flying all over the place, the amazing thing about a dog when he shakes is that more often than not the nose stays perfectly still, it is almost as though this is the pivotal point of the body.

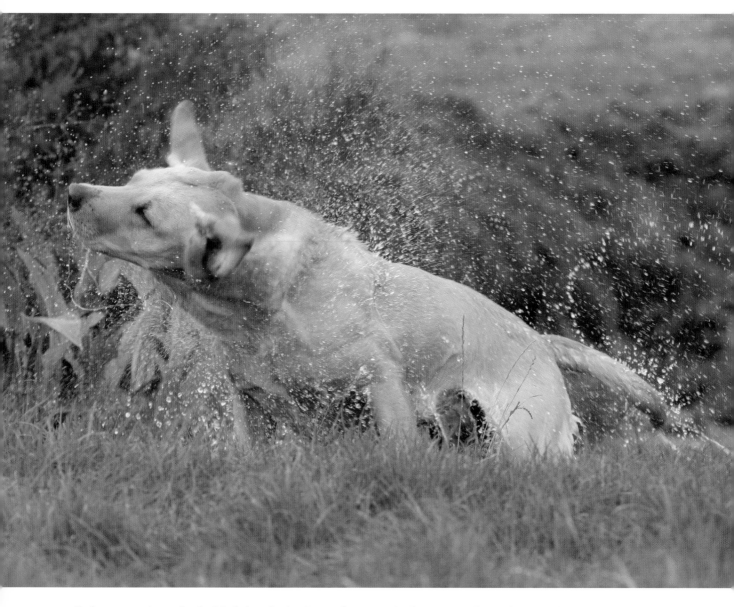

I always watch out for the 'shake' as the dog leaves the water. Jowls, water and ears fly everywhere but quite often the dog's nose will stay perfectly still.

Photographing dogs for a living is not glamorous and at times it's not pretty. I don't have the luxury of working in a nice warm studio with constant and controllable light. On the whole I work outside and in all weathers and lighting conditions, I have had to learn to adapt and work with the elements and during the summer of 2007 all my experience and skill was called upon. May Bank Holiday was a total washout and I was covering the highest profile-working test in the UK, The International Retriever Event. Teams from all over Europe compete against each other in two days of demanding working tests and that year the weather proved to be as difficult as the tests. Fortunately my camera gear is weather protected and can put up with all but the worst downpours but torrential rain and freezing temperatures made life very hard. However, despite the conditions I did manage to get some really good images and they graphically tell the story of a miserable two days.

One test was held alongside a lake that had been recently dredged and the spoil had been spread over the bankside, which left it looking like a scene from a World War I war movie. The dogs had to negotiate the mud, swim out into the lake, get a retrieve and then head back to their handlers. It took me a couple of attempts to work out where the majority of the dogs would come up over the bank but once I had worked it out I managed consistently to get the shots. All I can remember is thinking how cold my hands were and how good the dogs looked soaking wet and covered in a layer of stinking slimy mud. After spending three hours kneeling and crouching taking the photographs I realised that I was also soaking wet and covered in a layer of stinking slimy mud…like I said… glamorous it isn't!

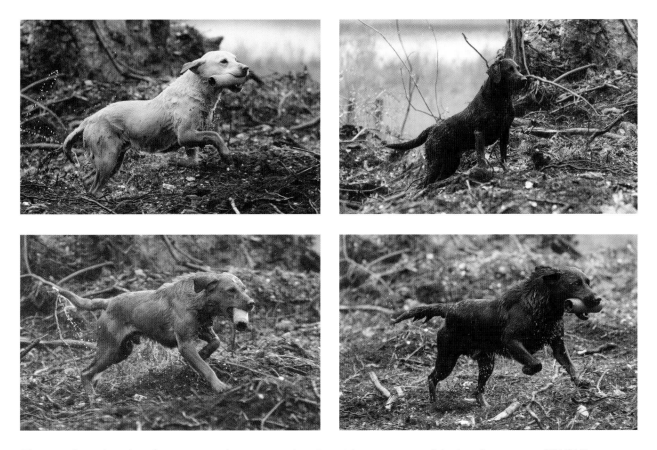

Photographing dogs for a living is not glamorous and at times it's not pretty and during the summer of 2007 I got very wet and very muddy photographing these Labs during an international working test.

There is simply no doubt that the Labrador retriever was born to work. They excel at retrieving no matter what the weather or the terrain, are faithful friends and fine shooting companions but that is only part of the Labrador's varied repertoire.

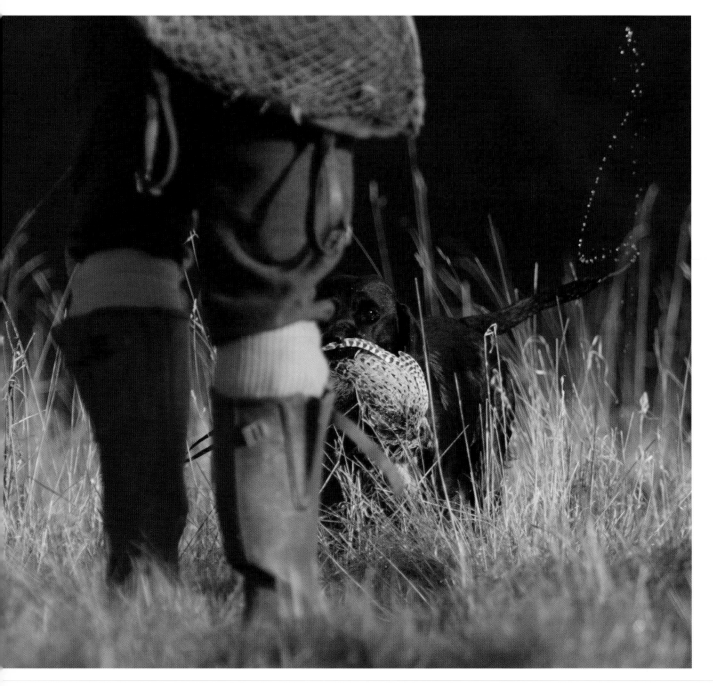

A job well done...

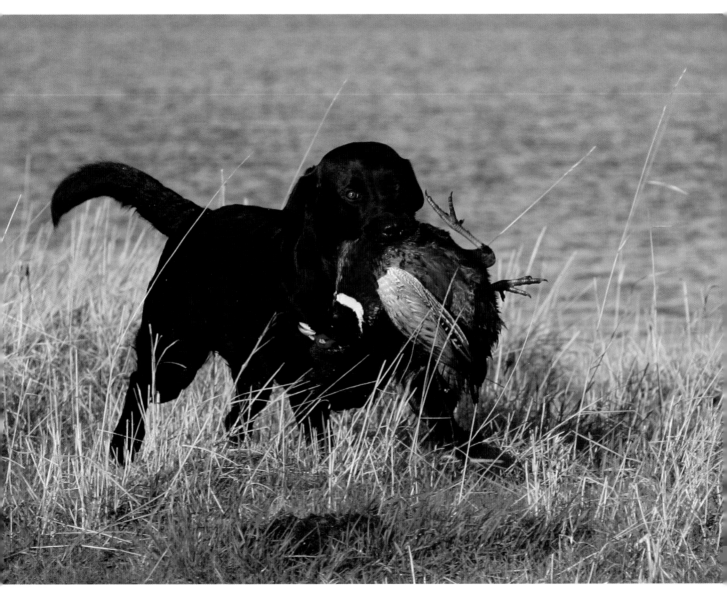

A bright sunny day early in the shooting season helps to show this black dog at his best.

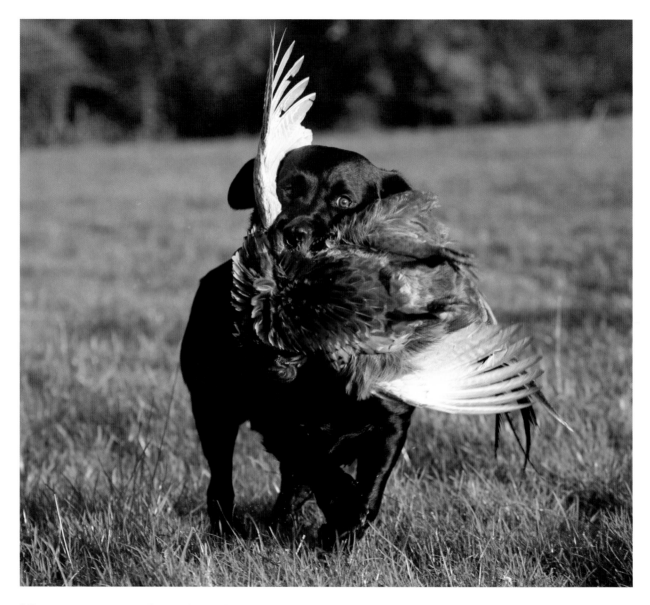

Wings sometimes get in the way but nothing deters a Labrador from getting on with his job.

2. THE VERSATILE LAB
Agility and flyball

The Labrador is such a versatile dog and can turn its paws to many different activities and this is one of the many reasons it is so popular. Every weekend throughout the year owners and their dogs travel the country taking part in agility and flyball events and although these competitions are dominated by the Border collie, the Labs do very well and both sports make the most of the dogs' athleticism and their natural desire to retrieve. For those who have never been to an agility competition there are basically a series of obstacles that the dogs have to jump, climb over or run through and all this is run against the clock.

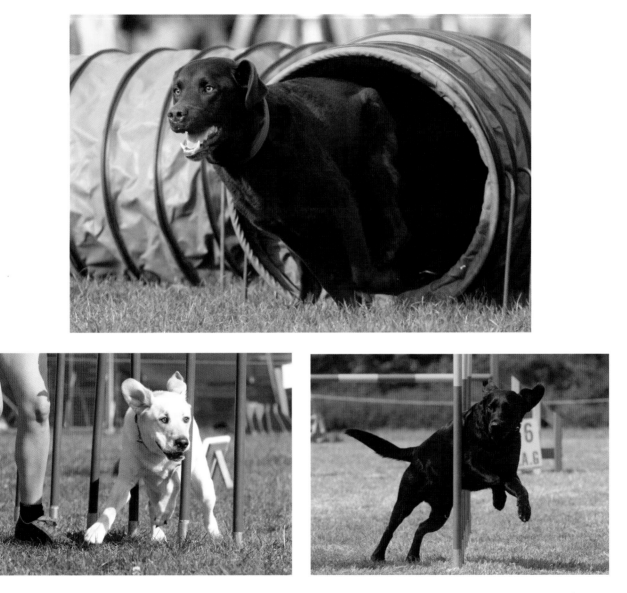

The Labrador is a very versatile dog and is just as at home running around an agility course as it is working in the shooting field.

Just as in show jumping, if the dog refuses or knocks over a fence it will pick up penalty points. There are various pieces of equipment and many of them can be compared to what the dog would see in the working field. One of my favourite pieces to photograph is the long jump (could this be an open ditch?) and quite often the dogs are already *on angle* ready to tackle the next obstacle, which may be the weaves.

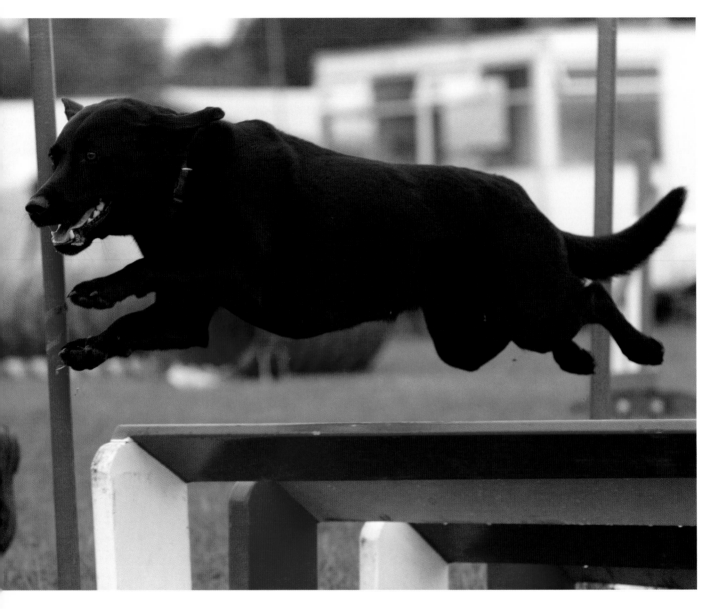

My favourite agility shot is the long jump. The dogs really have to stretch to get over the obstacle.

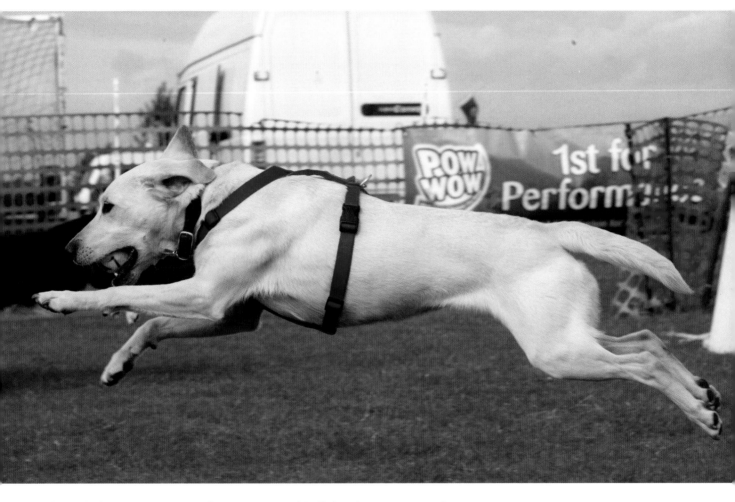

Although there are not many Labs competing in flyball they do seem to enjoy the excitement.

The weaves are a series of coloured poles that the dog has to snake its way through (similar to running through a sapling plantation for an injured bird). The really good dogs learn to skip through them and this always makes for some good flying ear shots. Anyone who has the view that Labradors are fat and lazy dogs should take themselves off to an agility event and watch them.

Flyball really is a high action and very noisy sport but Labs love it – it taps into their natural and sometimes manic desire to retrieve. The dogs are trained to become obsessed with a tennis ball; this really isn't too difficult with this breed. They are then introduced to the circuit; there are a series of low hurdles, which the dogs race down and at the end is a box that holds a tennis ball. The dogs are trained to jump on the box that releases a plunger and this pushes the ball into a waiting mouth.

The really exciting part for the Lab is that on race day they compete in a team of four and it is a race against two teams. This sport is great fun for all concerned and outside of gundog work it could have been invented for the Labrador, they can be as noisy as they like, they can run and jump and at the end of it get to bring back a ball to their very happy owner…happy days. In fact give any Labrador a tennis ball and you will have a friend for life – they are never happier than when they are running around with something in their mouths.

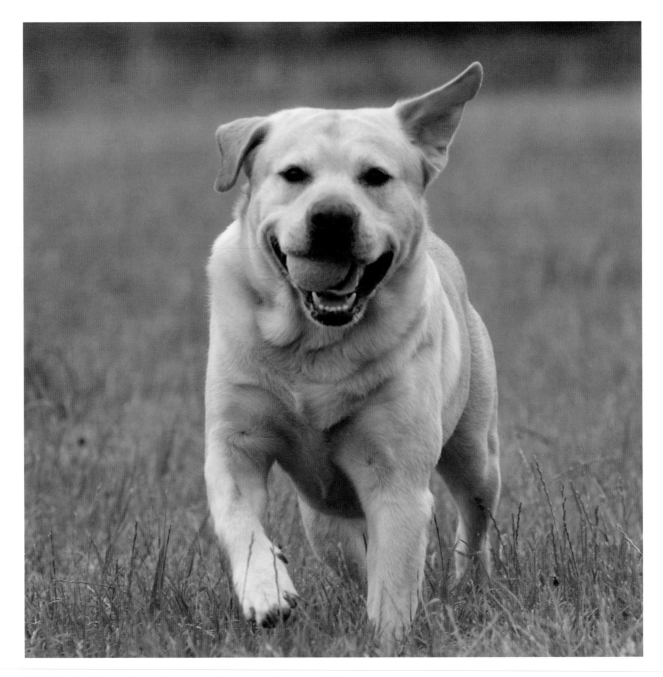

'Playing fetch is my favourite game…it even makes me smile.'

Puppies

There is something overly cute about Labrador puppies; they have an innocence and a cheekiness all rolled into a non-stop bundle of fun. I enjoy photographing all breeds of puppies but spending time lying down on my stomach, camera focused on a mischievous bunch of Lab pups is just about as good as it gets.

ABOVE:
Knowing your subject is as important as knowing how to take the photograph. This pup had just had its dinner and settled down for an afternoon siesta.

To get this intimate portrait I had to crawl along on my stomach trying not to disturb the dozing pup...the look on his face says it all!

This pup looks most uncomfortable but when it is time for a sleep even an old sheep hurdle will double up as a pillow.

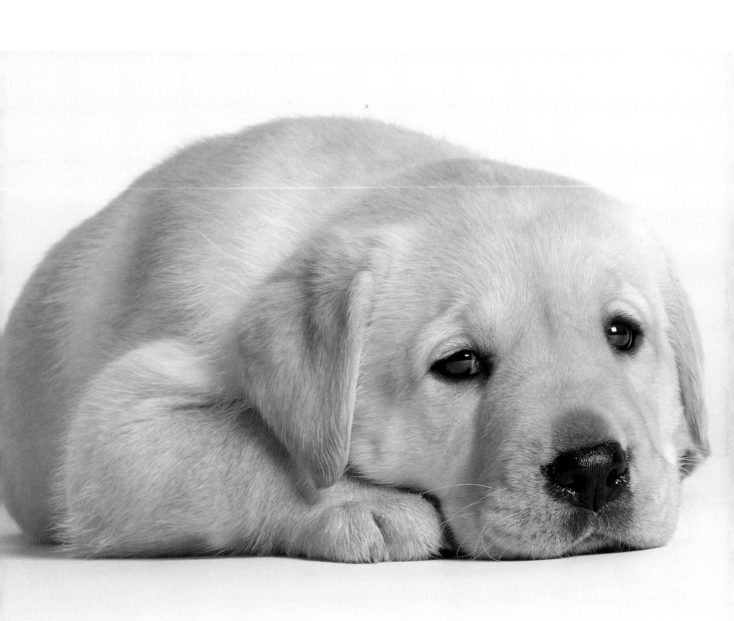

This particular photograph was taken for a commercial client and always reminds me of a sleeping seal pup.

I wanted to photograph a litter of Lab pups from their first few weeks of life but due to other work commitments I ended up using two separate litters. Very young puppies can actually be quite difficult to photograph, as they really don't do very much and their eyes are still shut, also if they are in a whelping box it doesn't really make for a nice backdrop and if the bitch and pups are black it really is a nightmare. Fortunately the first litter had a mixture of yellows and blacks and as they were only two weeks old I opted for some intimate close-ups. The pups had just fed and were fast asleep. It never fails to amaze me the contorted positions that very young pups manage to get to sleep in; it is also an amazing feat of nature that something so small can grow into something so large in comparison. When you consider the pup's head is not much bigger than the bitch's paw that is a lot of growing!

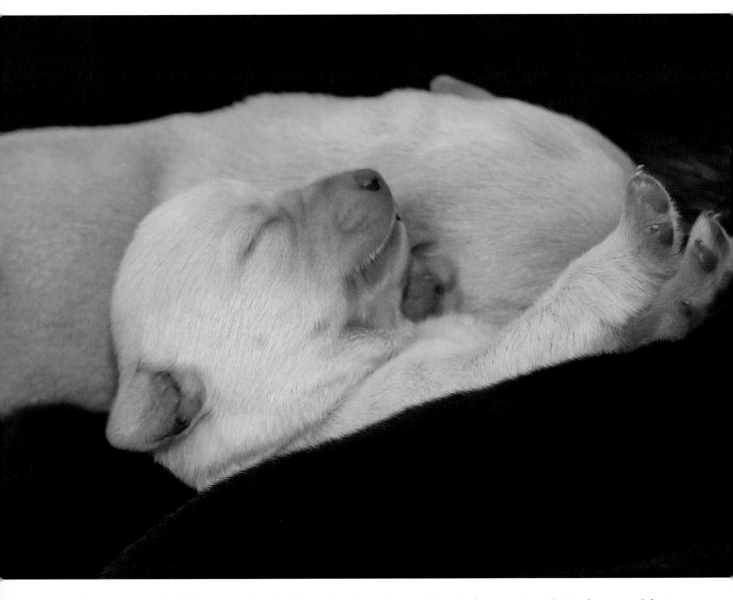

At just two weeks old this tiny yellow bitch has a lot of growing to do but in the meantime it's simply a case of sleeping and eating.

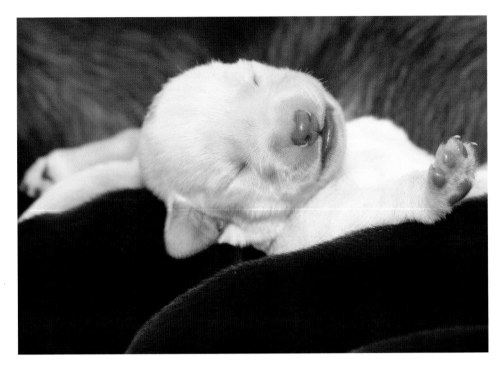

Young pups can be very difficult to photograph; fortunately there were a mixture of blacks and yellows in this litter of two-week-old puppies

How can something so small go into something so large...nature is a wonderful thing.

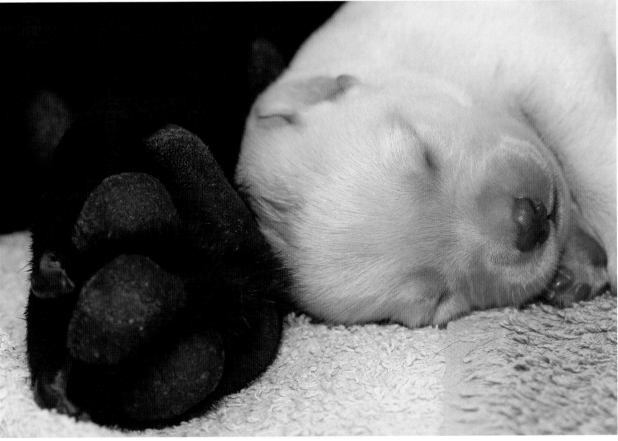

A few weeks later I arranged a session with some six-week-old puppies and they were a different ball game altogether. I gave this bunch a few props and then let them get on with it and tried not to get too distracted with their antics so that I missed any photo opportunities. It didn't take me long to identify the best subjects and it doesn't always have to be the one that 'is in your face'. One little black pup seemed to be quite happy to watch his brothers and sisters from a distance and would sneak up behind a pair of boots just to check out what was going on.

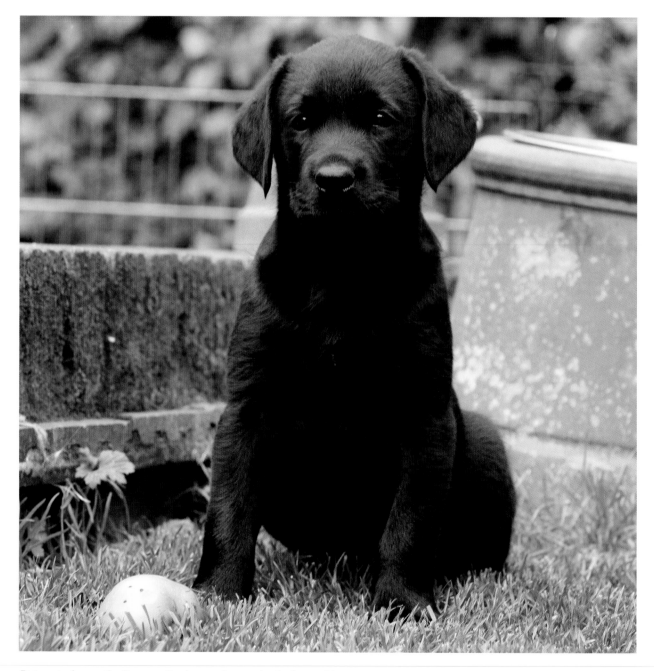

It is not always the 'in your face' pups that make the best subjects.

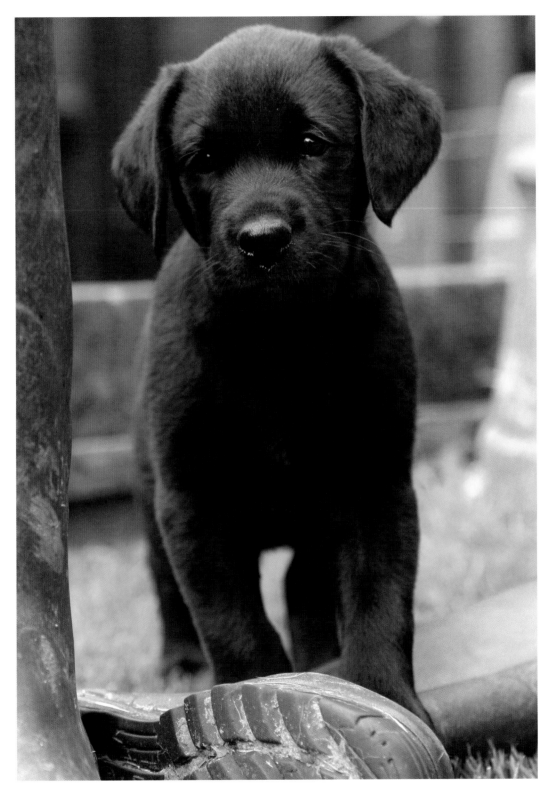

'That's better I can hide behind these boots and no one will see me.'

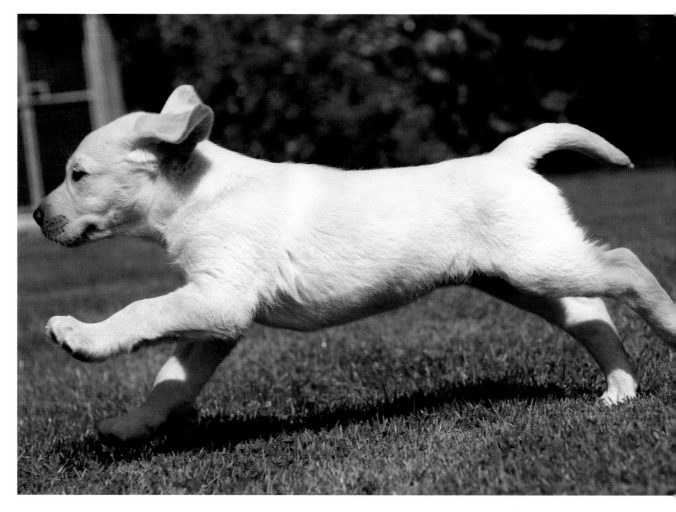

There is no doubting the conformation of this six-week-old yellow Lab pup.

Funnily enough the yellow pups were really going for it, nothing to do with the saying blondes have more fun I am sure! Out of each session I hope to get an image that is just a little bit special and as I was getting ready to pack up I saw a little yellow bitch peek from behind a tree and I managed to grab a few quick shots. Personally I love the light and the vulnerable look on her face, the texture of the tree adds some contrast to the image…to the purist it may not be perfect but I like it.

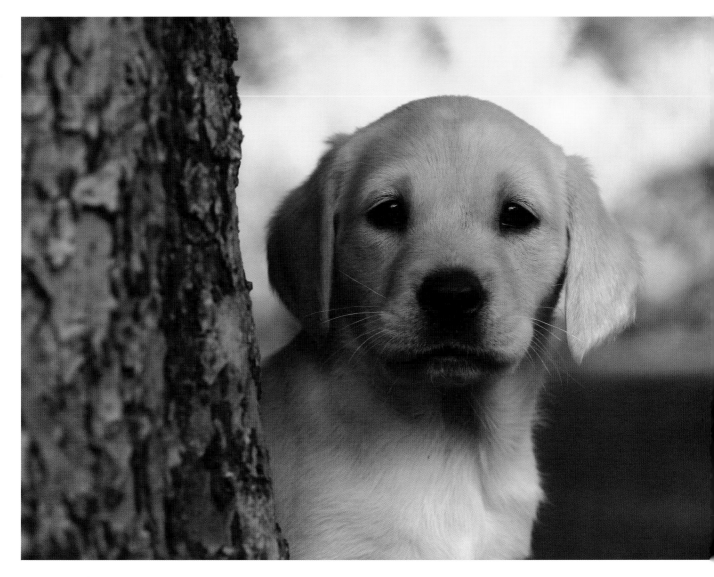

Observation is the key to good photography. As this little yellow bitch peeked her head around the trunk of a tree I managed to get a few quick shots. It was my favourite from very a hectic session.

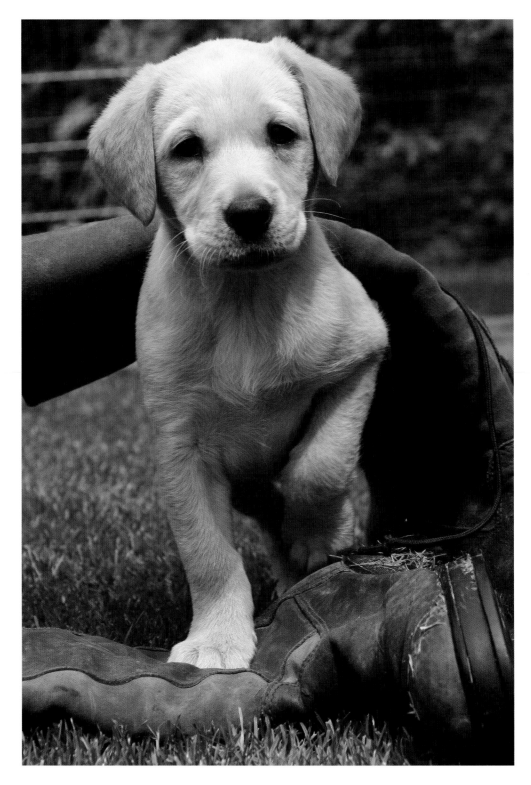

At six weeks old there has been a dramatic change not only in the size of the pups but also in their playful antics.

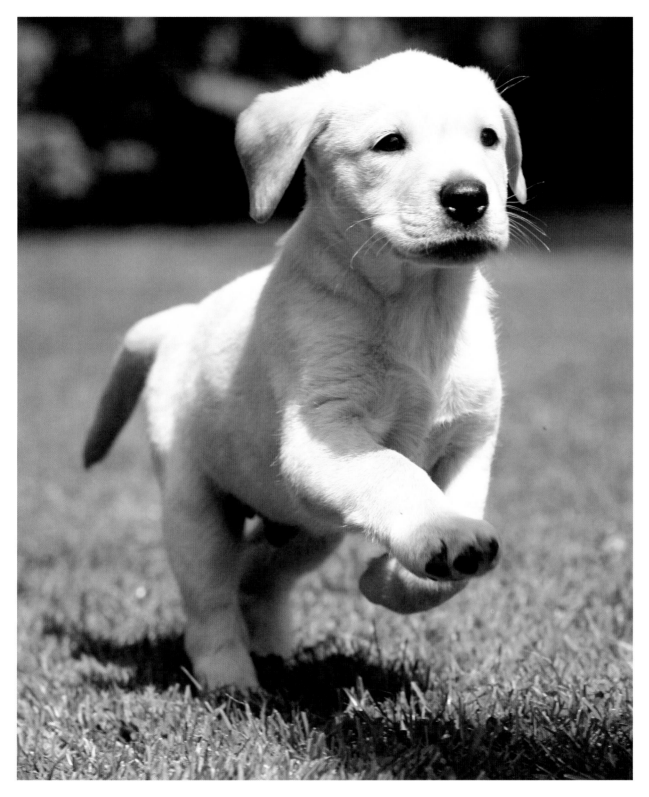

Life is fun at six weeks old...

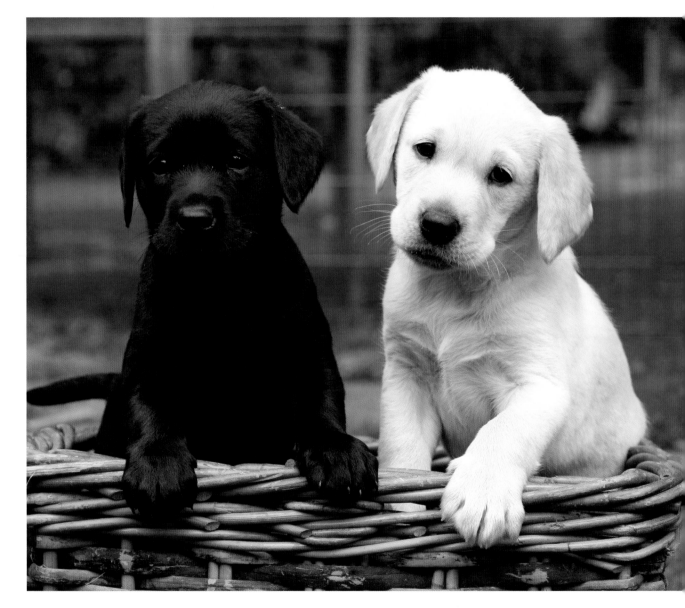

A basketful of trouble...!

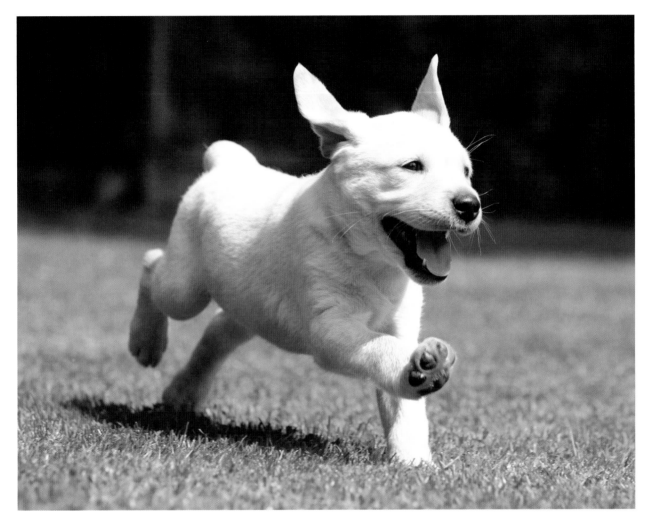

Innocence and cheekiness all rolled into one...and just check out those ears.

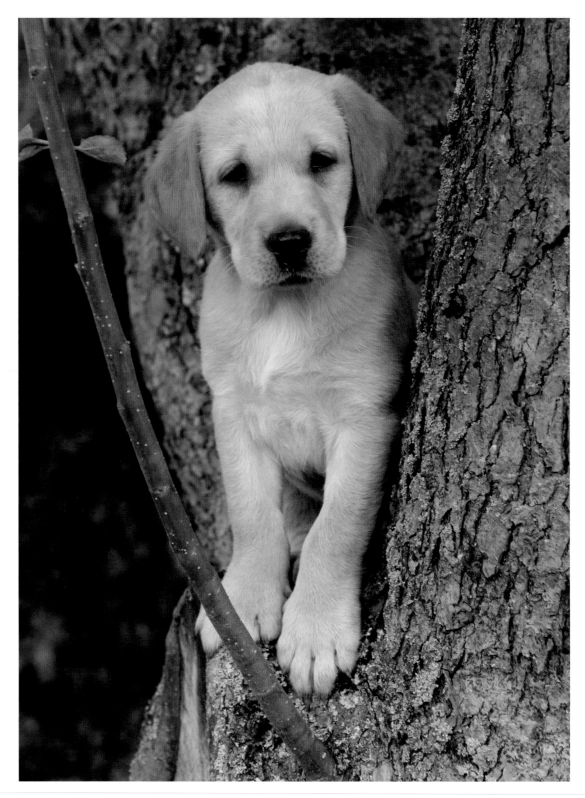

'When I grow up I am going to be a cat!'

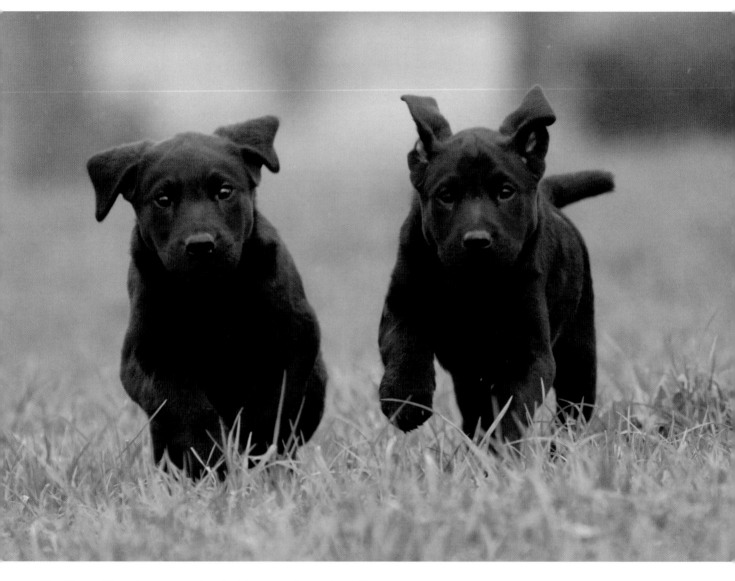

Double trouble... these two are just looking to get into mischief.

Just a few days later I returned for another session with the same litter and this time I had decided to arrive just after feeding time so they would have a mad half hour and then settle down for an afternoon siesta. Dog photography is as much about knowing your subject matter intimately, as it is understanding the mechanics and art of taking pictures. It didn't take long before the pups started to settle down and I could get to work. They were so dozy that I was even able to reposition carefully a couple of paws just so that I could get the shot I wanted. It wasn't long before I found myself sitting and watching the pups and I am sure I could even hear a faint snore. Pups really are time wasters!

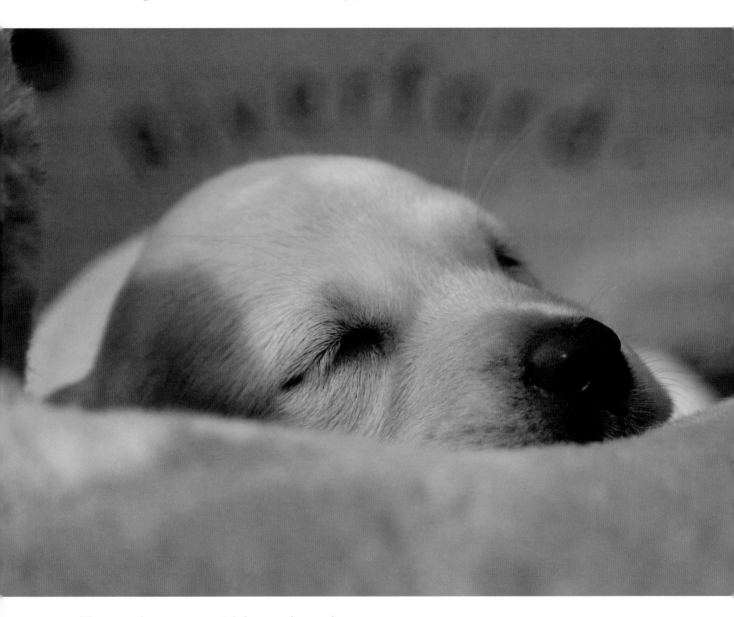

There is nothing more peaceful than watching a sleeping puppy.

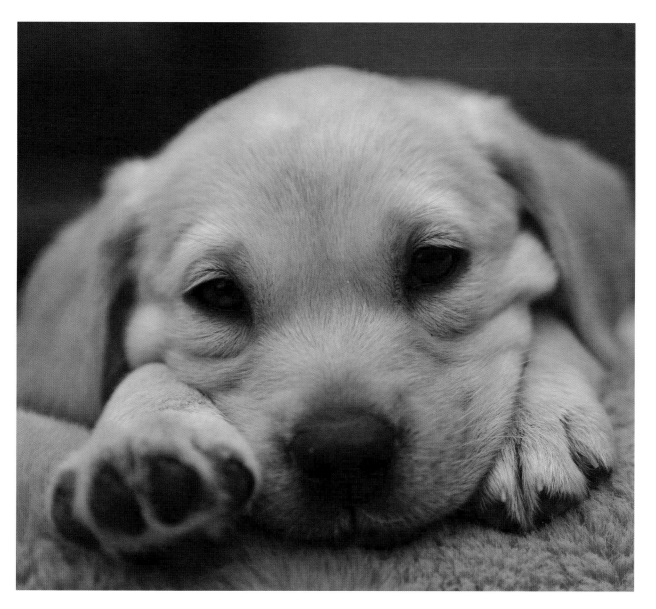

A full belly, a cosy blanket and a clear conscience…it really is a dog's life!

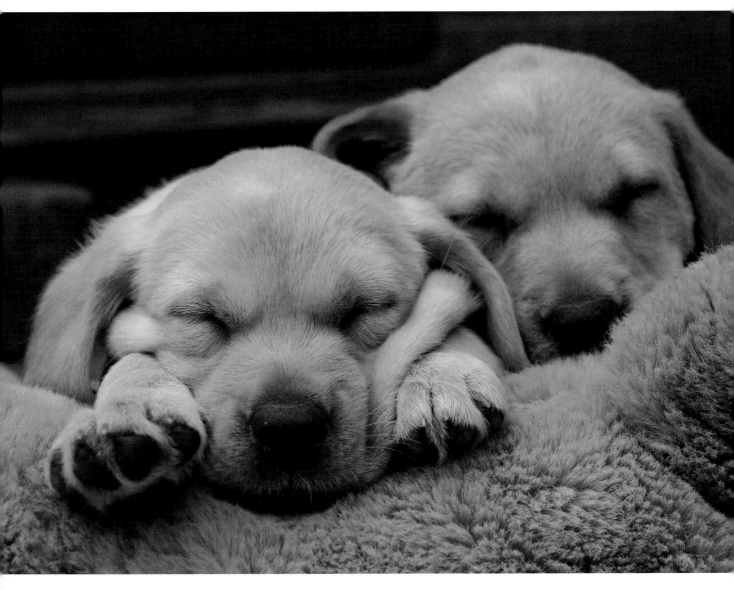

You can't get much cuter than this. I had to be careful I didn't spend too much time just watching the pups rather than photographing them.

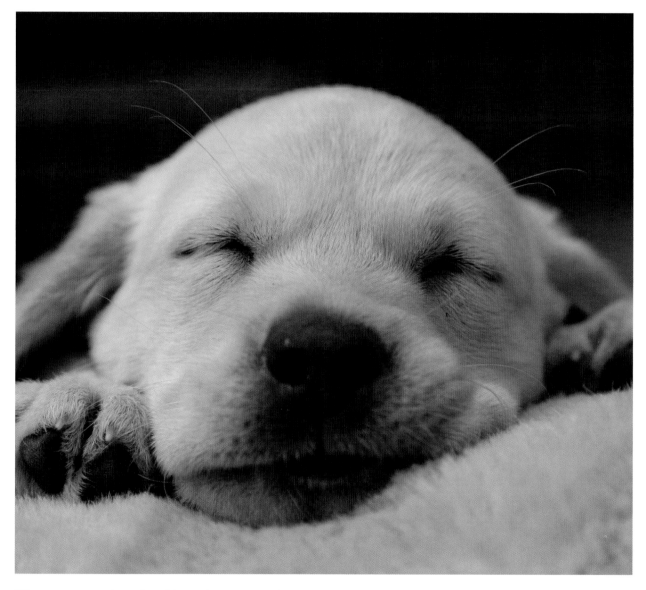

The pups were so sleepy I could quietly reposition the paws just so I could get the perfect shot.

3. 'THAT SPECIAL LOOK'

Each and every one of us who owns a dog will know 'that particular' look that just sums up the dog's personality and I see it as my job to capture that in my photographs. I get great pleasure when an owner looks at an image and declares that it looks just like Bonzo...well it would it's a photograph!

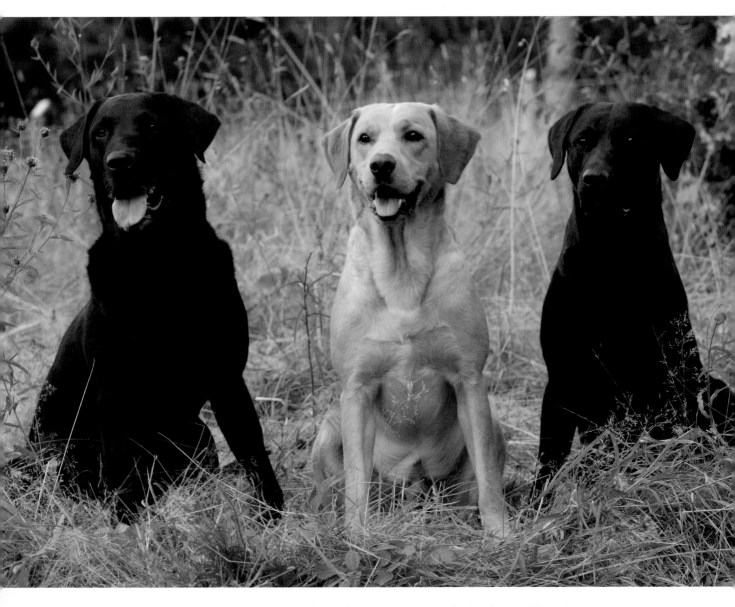

This group portrait consists of dad, litter brother and sister...can you see the family resemblance!

OPPOSITE: *A young fox-red pup has his first portrait taken.*

Over the years I have developed many methods to attract the dog's attention and Labs just love the squeakers I use, mind you I have to be a bit careful, as it is not unusual for me to find a rather large and boisterous Lab sitting on my lap trying to be my best friend.

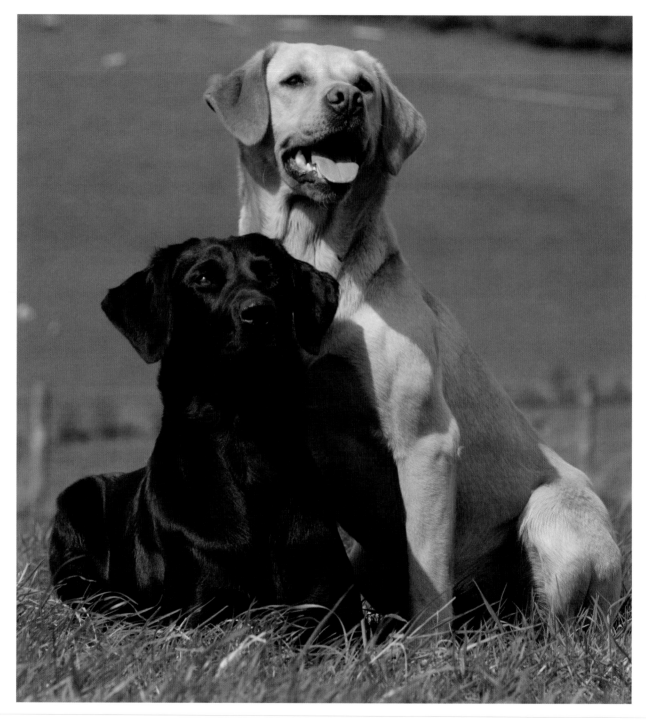

A good-looking pair of dogs in perfect surroundings.

I must admit I do get an incredible buzz out of capturing a Labrador in full action whether it be on a grouse moor retrieving a bird or flying over a jump in an agility competition but these shots are instinctive, they happen 'on the fly' but when I get asked to do straight portraits the creative juices do start to flow.

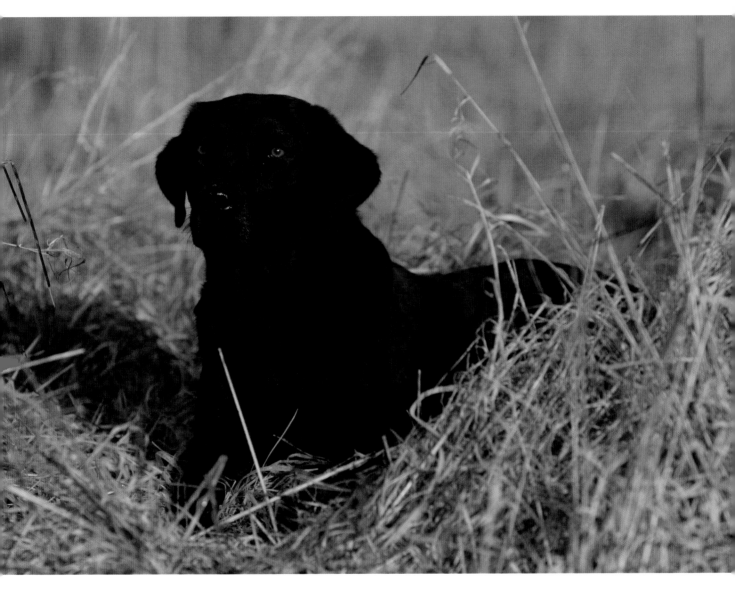

Taking a good photographic portrait is all about capturing the personality of the dog and putting it in context.

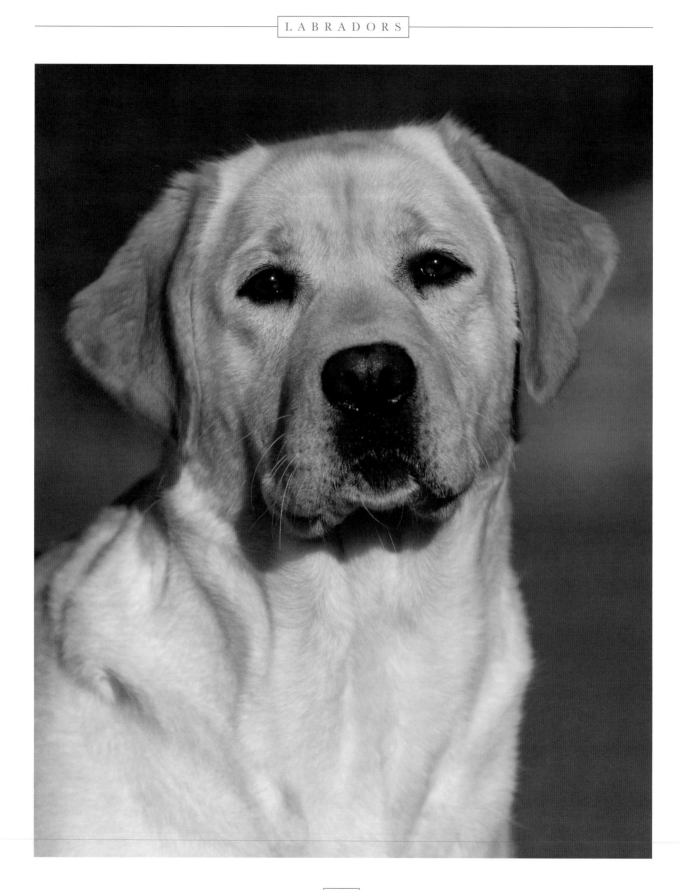

Any dog enthusiast will have seen a Border collie work a flock of sheep and the intensity that they have in their eye, in fact they are known for the way they can hold a flock just by looking at them. You may think that there isn't another breed that can have that same concentration but you just watch a Labrador marking a shot bird waiting for his handler to give the command to make the retrieve.

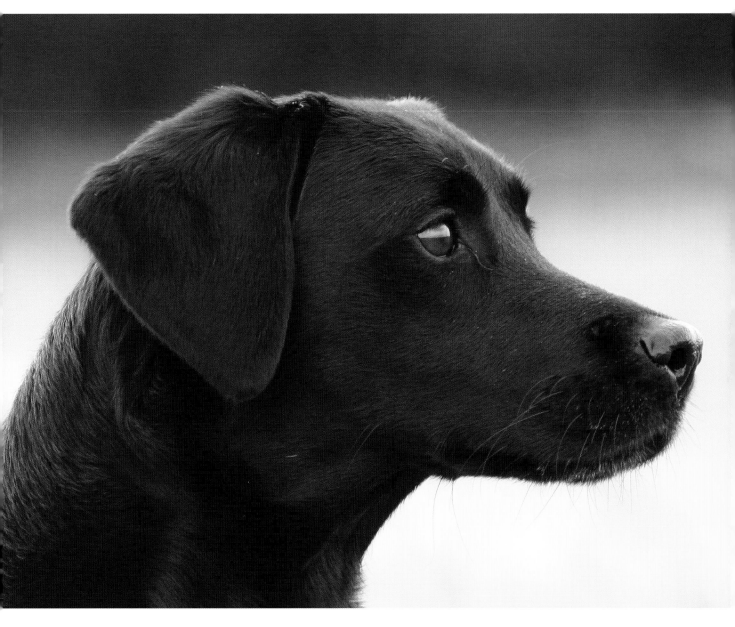

The concentration in this Labrador's eyes is as intense as any Border Collie working a flock of sheep.

OPPOSITE: A typical show bred Labrador classically good-looking and still capable of doing a day's work.

I am always looking for new angles and over the past few years one of my favourites it what I call 'shadowing'. Now this is not where I am looking to get the sun to cast a shadow of the dog but it is where I try and get two or if I am lucky three heads or bodies in line or just slightly off and then I focus on the nearest dog and throw the others that are behind him out of focus thus creating a kind of shadow. There has to be some artistic licence of course but this technique works so well with Labradors especially if one is yellow and the other is black or one is old and the other is young. I have become quite obsessive about this and I do get some funny looks as I bob up and down or shuffle along on my backside trying to get the perfect angle. These shots always work best if they occur naturally as if the handler tries to set them up the dogs seem to sense that something is happening and they start to tense and the moment is lost. Very occasionally I will strike lucky and get an action shot where two Labs are running and their body shapes are almost the same, technically these photographs are a nightmare to get right but when everything falls into place they can make a fantastic image.

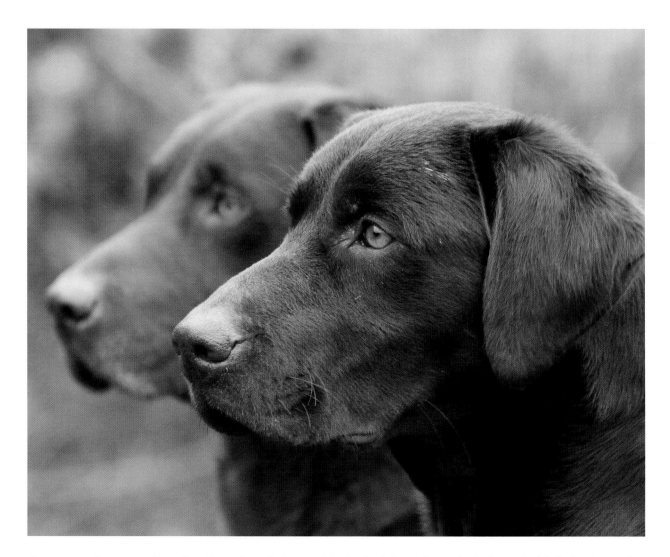

ABOVE AND OPPOSITE: One of my favourite techniques – 'shadowing'. It works particularly well with Labradors and owners get quite amused as I constantly shuffle around to get in the right position without disturbing the dogs.

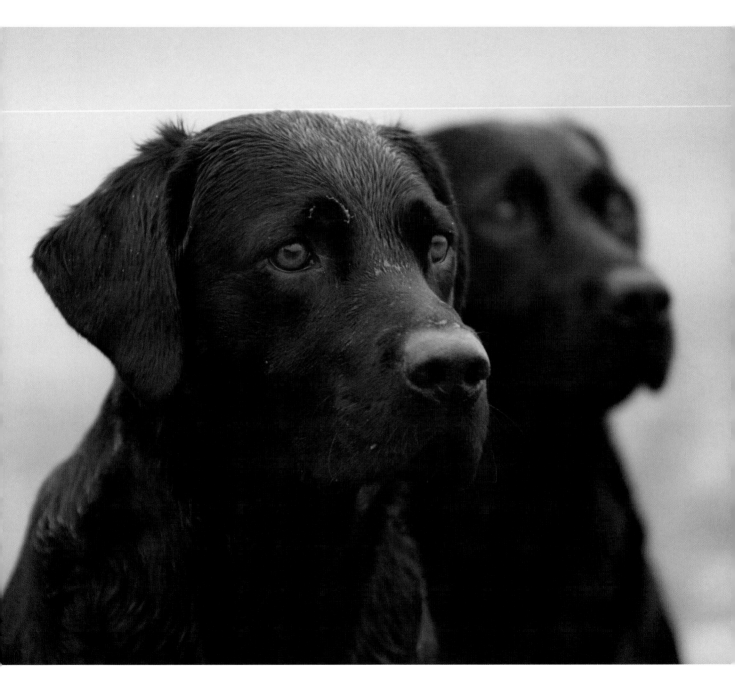

Given the choice I would always opt to take photos in natural surroundings and when I am out in the field I am like a radar, constantly scanning the dogs to try and pick up on any little 'personal' habits or foibles that they may have.

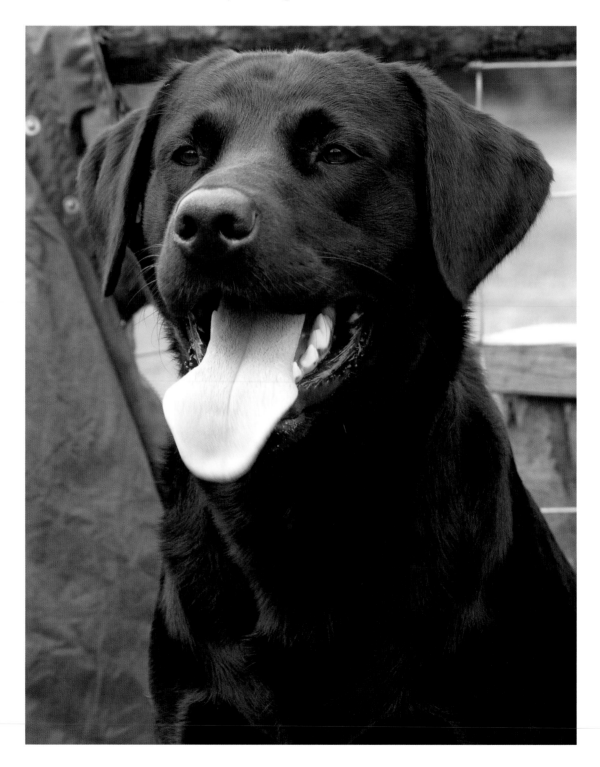

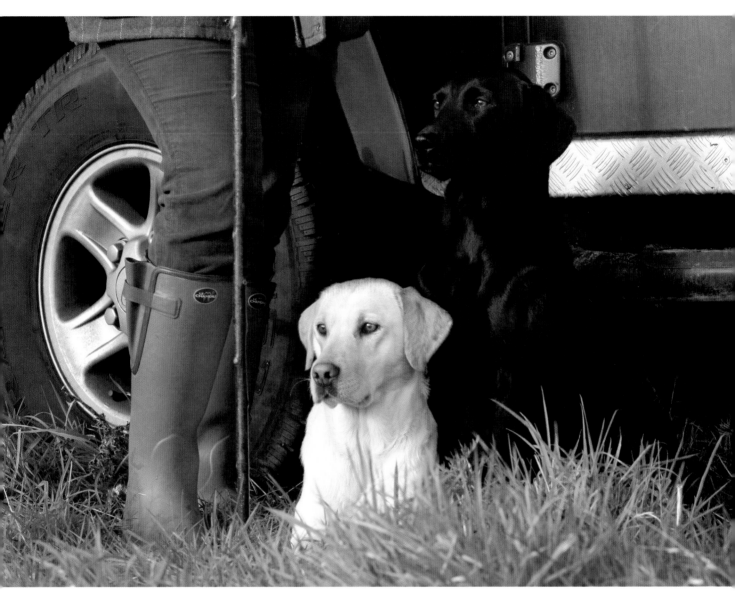

There is no doubting the lifestyle that these two Labradors enjoy.

OPPOSITE: *Personally I like to see the tongue of a black Labrador when photographing them as it helps to break up the face.*

I remember being out on a shoot and watching a particular black Lab. He was a nice looking dog and I had already earmarked him as a potential 'action' subject but as the day went on I noticed that every time he settled down for a rest he natu- rally crossed his front paws. I spent ages trying to get into a position where I could get a clear shot of the dog but every time I got down to his eye level his tail would start wagging and he would shift his position and un-cross his legs.

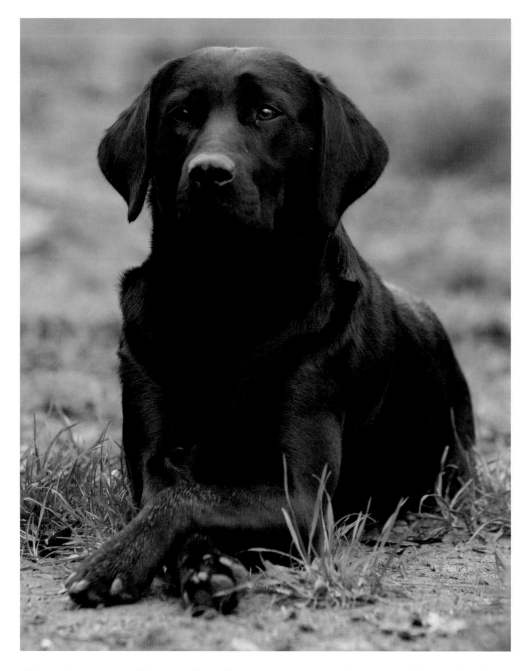

Observation is time well spent and it took me some time to get this portrait of a very relaxed black Lab.

Eventually I got his owner to stand to one side and this drew the dog's eye away from me and I was able to get just one shot before he moved. In the big scheme of things not a dramatic image but one that captured the dog's personality and a particular habit that he has developed and one that will always remind the owner of his dog and the time they spent together.

Another classic pose is the 'head on paws' or as I call it 'can we go home now…I've really had enough!' I really love these shots but it is amazing how many of the owners tell their dogs to sit up as soon as they drop their heads and I have to be really quick to either take the shot or ask the owner to leave the dog as it is. I don't know what goes on in a Labrador's mind, I am not a trained dog behaviourist but I guess I see and deal with more Labs in a year than most people and when they are relaxed and perhaps just dropping off for a quick nap there is always a peace and tranquility in their eyes. It must be nice not to have the worry of the human stress and strains of life and be able just to concentrate on the next bowl of food or the next walk…it really is a dog's life.

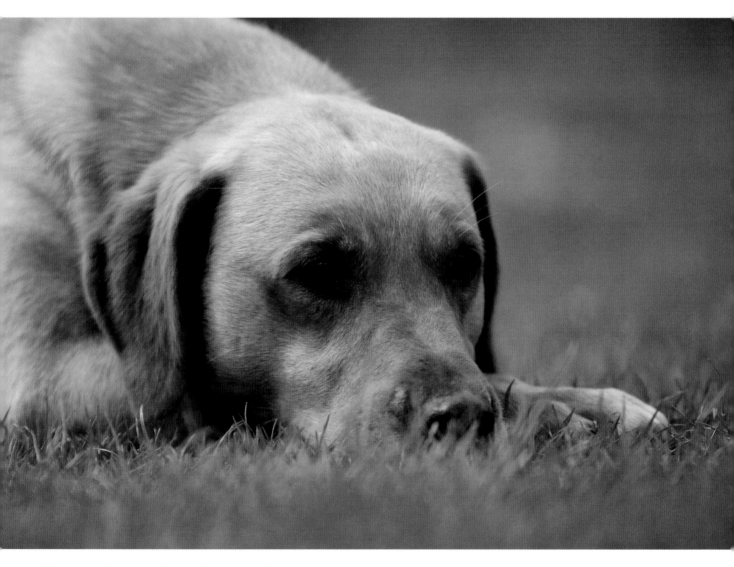

'Can we go home now I've really had enough…!'

One of my favourite all time Lab, or indeed any dog breed portrait was taken during a gundog training session. The black Lab was working a small stream which was in quite a dark and over-grown strip of woodland and as I stood watching him work the handler called him back and stopped him just in front of a fallen log. In a flash the dog was sent on and moved away but in my mind's eye I had just seen a magical photograph. I asked the handler to pull the dog back and to try and stop him at the log again. To get the right angle I slipped down the bank and got up to my knees in mud and very cold water. To be honest I wasn't hopeful that we could recreate what I had just seen but the dog had been well trained and as he came back to the log the sun came out and just as he stopped the light caught his face and I took a quick few shots. I knew I had something special, it was a classic grab shot, I had no time to compose the image properly, it just happened and I had a huge element of luck with me especially as the weather had been quite dull all day.

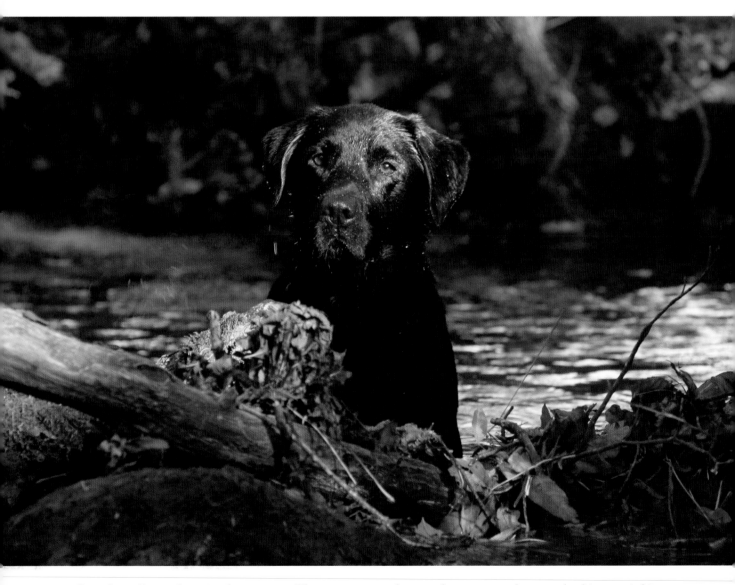

One of my all time favourite dog portraits. There are so many elements that come together to make this a special image.

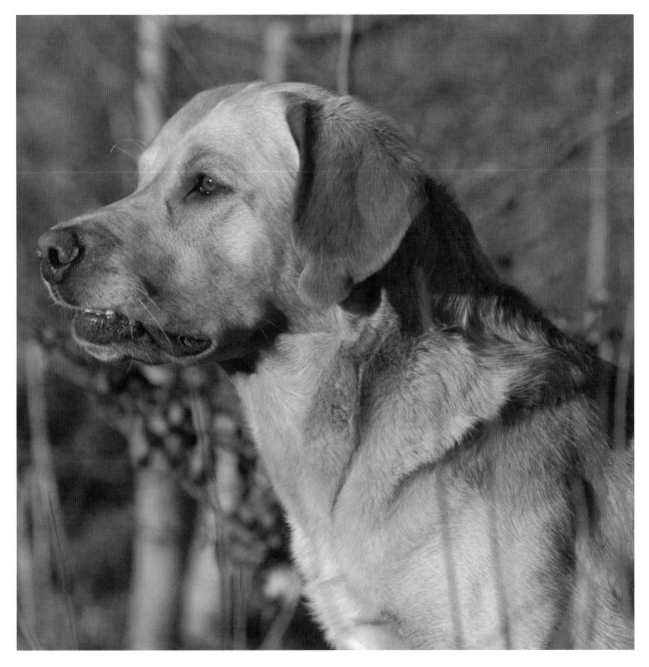

Labrador heads come in all different shapes and sizes and remember beauty is in the eyes of the beholder.

I have been asked many times what I like about that image and I have to say there are so many things, the lighting, the colours, and the look on the dog's face. I was lucky that the dog's eyes were such a nice rich brown instead of being dark like the eyes of some Labradors, but most of all I like the fact that I know this photograph gives the owner so much pleasure every time she looks at it.

Labrador heads come in all shapes and sizes and I do like to get a good head and shoulders or a sideways portrait especially if I can throw the background out of focus, which helps to emphasise the outline of the dog.

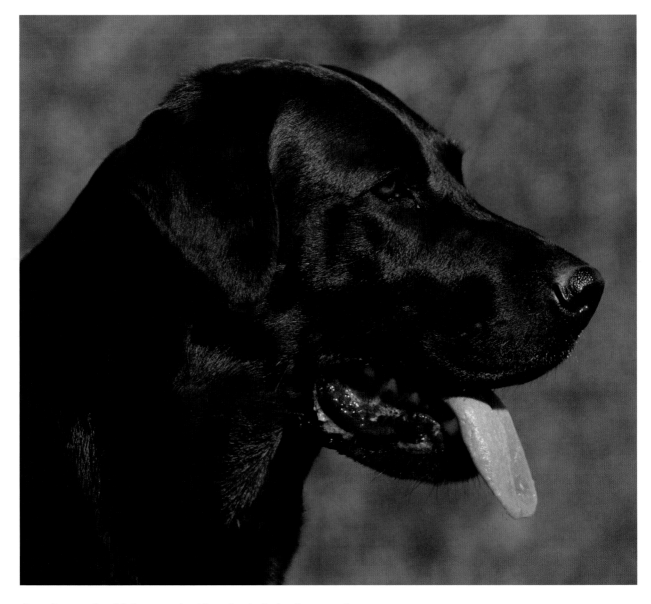

A good strong head helps to make this a classic Labrador portrait.

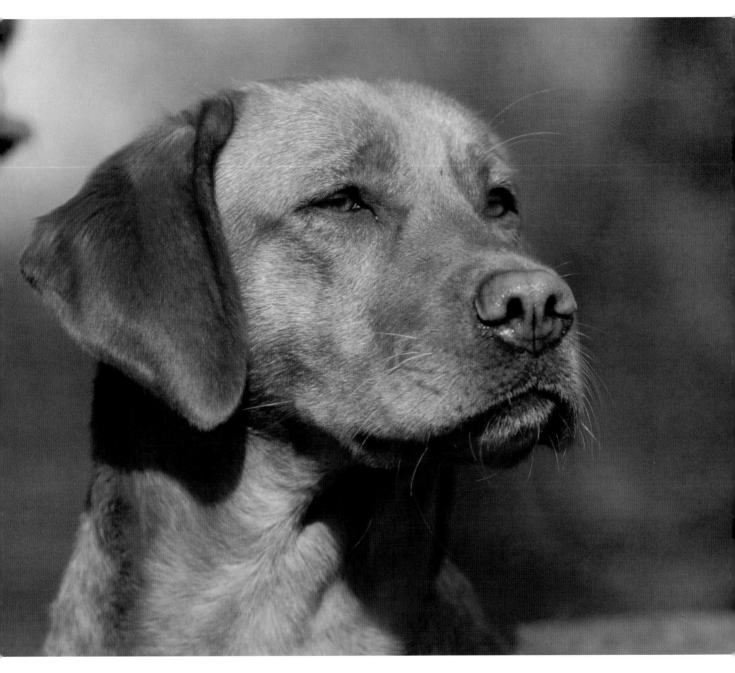

Notice how the dog's eyes are looking to the right but his nose is searching for scent to the left...

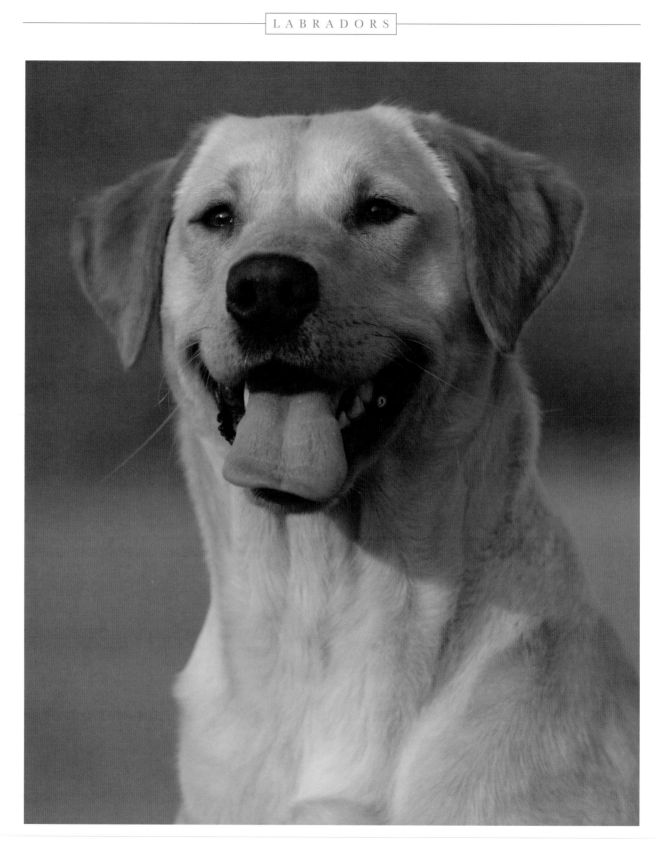

A simple head and shoulders portrait of a very nice looking yellow Lab.

Crufts

Every year I work for Nestlé Purina Petcare at Crufts, the largest dog show in the world, and over the four days and especially on gundog day I see plenty of Labradors. Each year we have a different studio set up and a couple of years ago we designed a living room complete with a miniature leather sofa and the Labs took to it just like they do water!

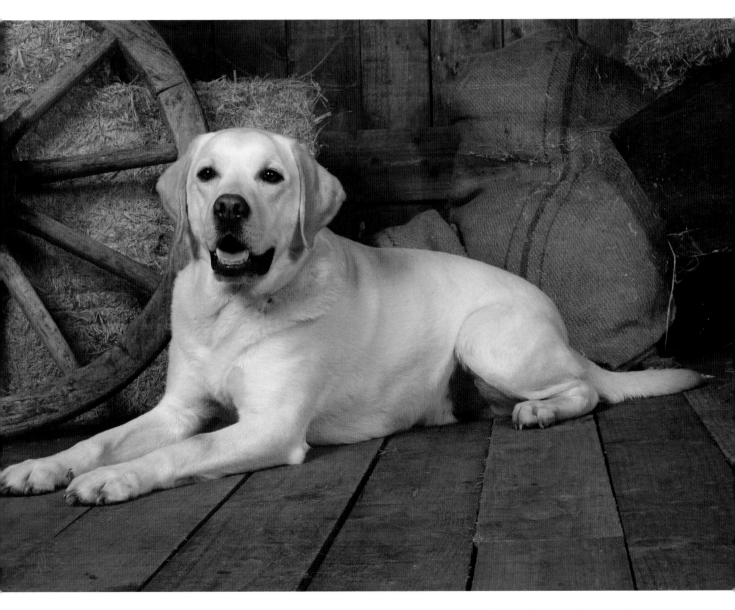

Although I prefer to photograph dogs in natural environments every year I work at Crufts and have a different studio set. This is a classic studio shot of a handsome yellow Lab.

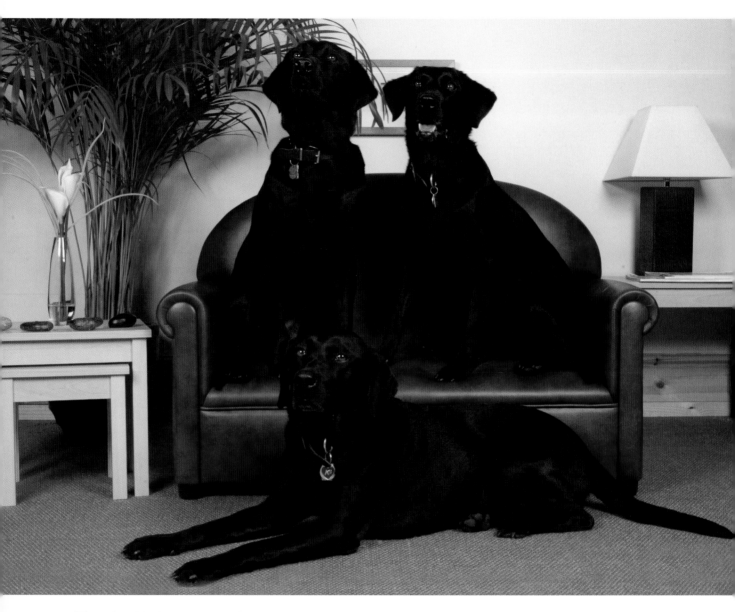

These three black Labs are regular customers at Crufts and they took to the miniature sofa like ducks to water.

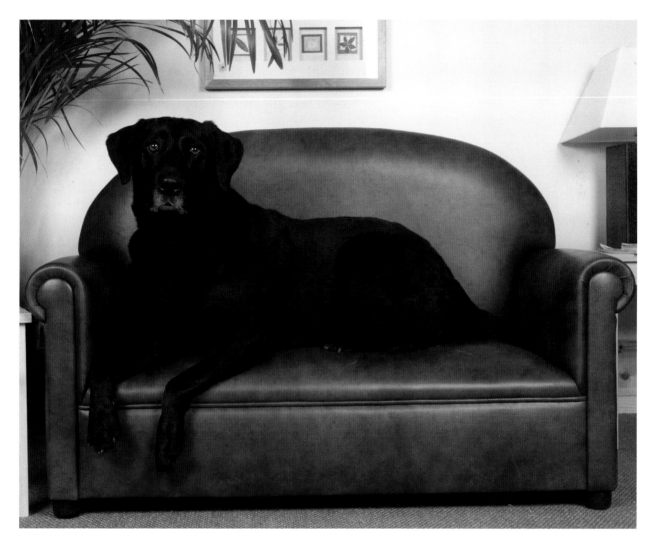

Who says dogs are not allowed on the furniture...!

They might be 'ruffty tuffty' dogs but they do like their comfort and needed very little encouragement to jump up on the sofa and settle down for a quick rest. One Labrador I always look forward to seeing is Endal and if one dog epitomises the versatility of the Labrador, Endal is that dog. Now I must say before I go on to tell a little of Endal's story that there are plenty of Labradors that are doing great work whether it be as guide dogs for blind people or hunting out explosives, but Endal is probably the most famous Labrador in recent years.

Endal

Endal's owner Allen Parton was severely injured whilst he was serving with the Royal Navy during the Gulf War and after spending five years in hospital his memory had totally obliterated, he couldn't remember his family, he had lost the ability to speak properly and was confined to a wheel chair. During the summer of 1997 Allen's wife Sandra took him to Canine Partners, which is a charity that trains dogs to help disabled people enjoy a greater degree of independence. Allen sat, his wheelchair parked in a corner, as self-conscious and withdrawn as he always was in public. Until, that is, his eye caught a young dog, resting from a training session. The dog wandered over to the wheelchair, accepted Allen's offer of a welcoming pat on the head and promptly dived on to his lap. It was Endal. Needless to say Endal changed Allen's life and in fact went on to save it. In 2002 Endal was awarded a Gold Medal from the PDSA (Peoples' Dispensary for Sick Animals). The medal is awarded to animals that that have shown outstanding devotion to their duties in time of peace. Allen had been knocked from his wheelchair by a reversing car; Endal rolled Allen's unconscious body into the recovery position, draped a blanket over him, nudged his mobile phone close to his face and then went to fetch help.

And that's not the end of Endal's awards; in 2004 he was given a Life Time Achievement Award, and was also named as UK Dog of the Millennium. Over the years he has not only helped Allen in practical ways such as shopping or opening doors he has also given Allen a purpose and it is always a great pleasure to catch up with this remarkable dog and his owner and if I ever have any doubt about the worth of the photographs I take this e-mail from Allen puts me back on the right track:

Having rebuilt a new life since my injury in 1991, I really can't think of a nicer place than to be than with you all at Crufts each year and meeting up at the various events throughout the year we attend. My greatest fear because of my head injury is that one day when Endal is no longer faithfully at my side, because of my memory problems, I will forget him. Over the years you have given us a fantastic record of our time together and we are so indebted to you for your kindness (and limitless patience!!!!), an unrepayable debt. Thank you never seems enough to say but is meant deep from the heart.

Apart from being a very special assistance dog Endal is a pretty good-looking Lab as well and has to be one of the easiest dogs to photograph and he is probably the only Lab that does not react in anyway to my squeakers... he is one laid back dog.

OPPOSITE: Endal is probably the most famous Labrador in recent years.

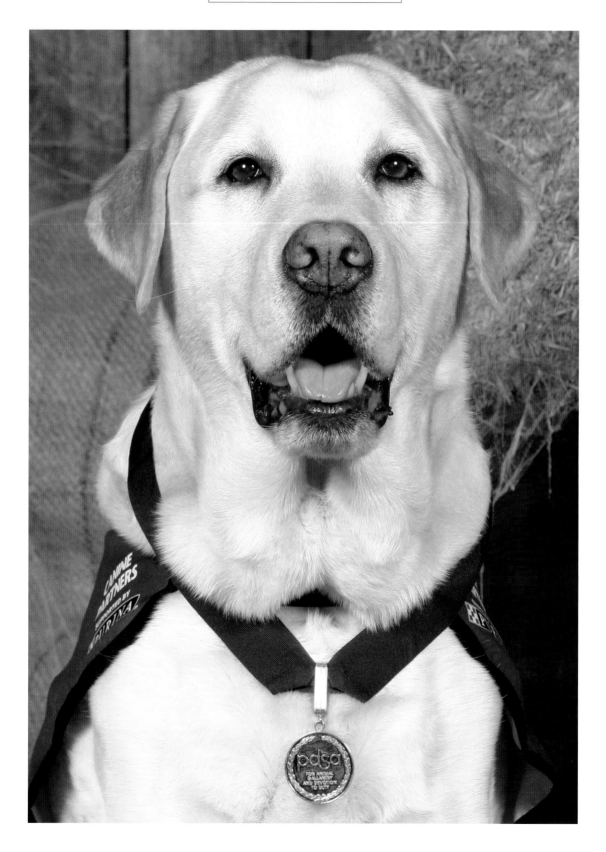

'Man Work'

One of the more unusual jobs I have seen a Labrador perform was at a display of what is known as 'Man Work'. Normally German Shepherds or other guarding type breeds dominate this kind of event but one of the trainers had taught a black Lab to pursue and attack a violent offender. A Labrador may not have the presence of a large Rottweiler but I was left in no doubt that this dog meant business, perhaps the overall idea was that it would catch the criminal and then retrieve it back to the waiting handler...just a thought!

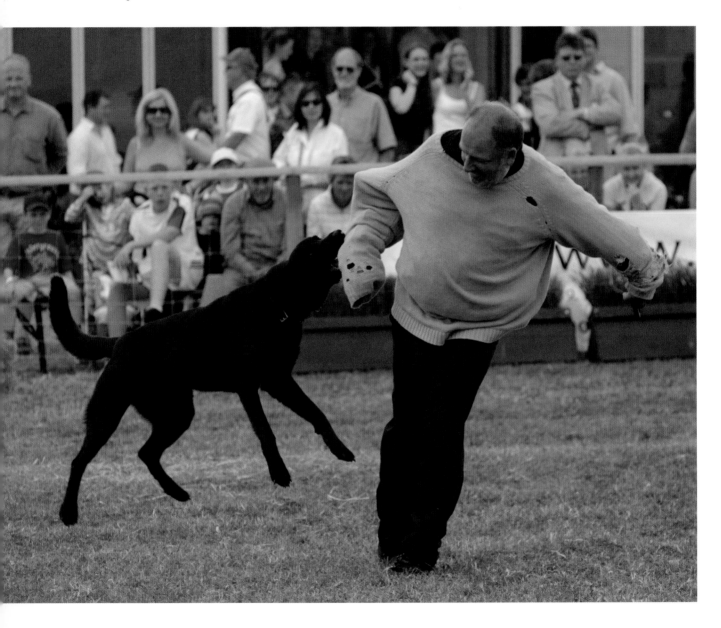

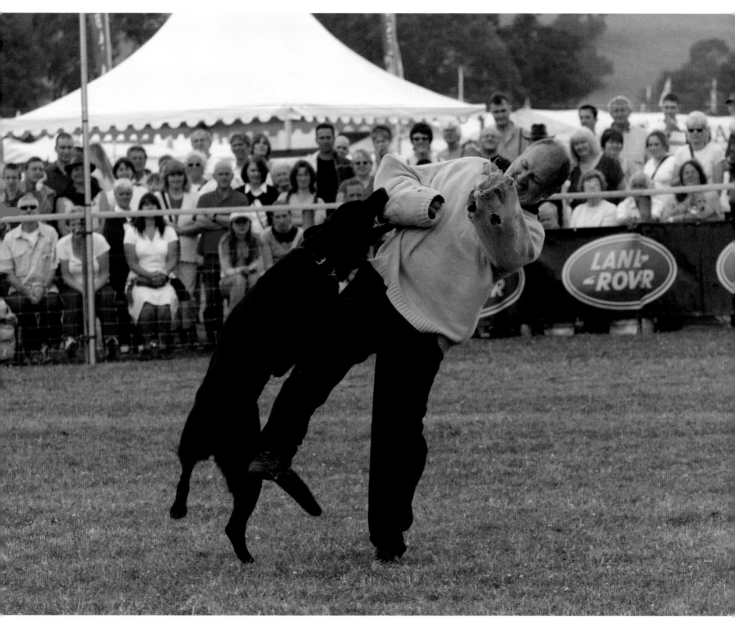

OPPOSITE AND ABOVE: A very unusual job for a Labrador...perhaps he could catch the criminal and then retrieve him back to the handler.

Older Labs

I have always thought that Labradors stay young for quite a long time and then they get old very quickly, they never seem to have a 'mid-life'. I like photographing old Labradors – they always seem to have an air about them; they are nearly always very laid back and it's quite often a case of, been there, seen that and done it.

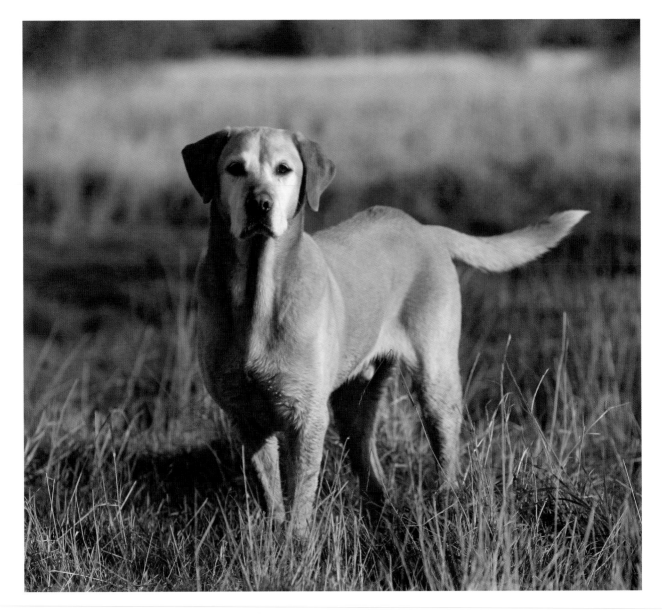

Age is no barrier when there are pheasants to hunt.

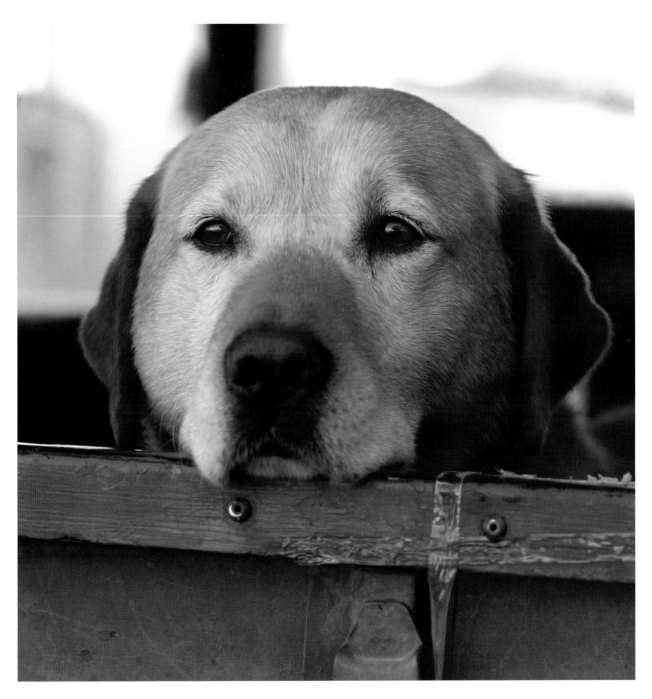

The body may be old but the mind is still very willing.

During a shoot day they seem to forget that they are in the winter of their lives and charge around as lively as a pup but given a break in proceedings they will find a nice spot in the sun and take advantage of the warming rays. It must be difficult for an elderly dog that has enjoyed being out with his master for all of his life and then as age starts to take its toll a new dog comes along and the old chap gets left behind.

I am not sure if dogs can think or whether everything they do is instinct but the Labradors that I know all have an uncanny knack for knowing when they are going out for a walk, off on a shooting trip or out for a day's agility competition.

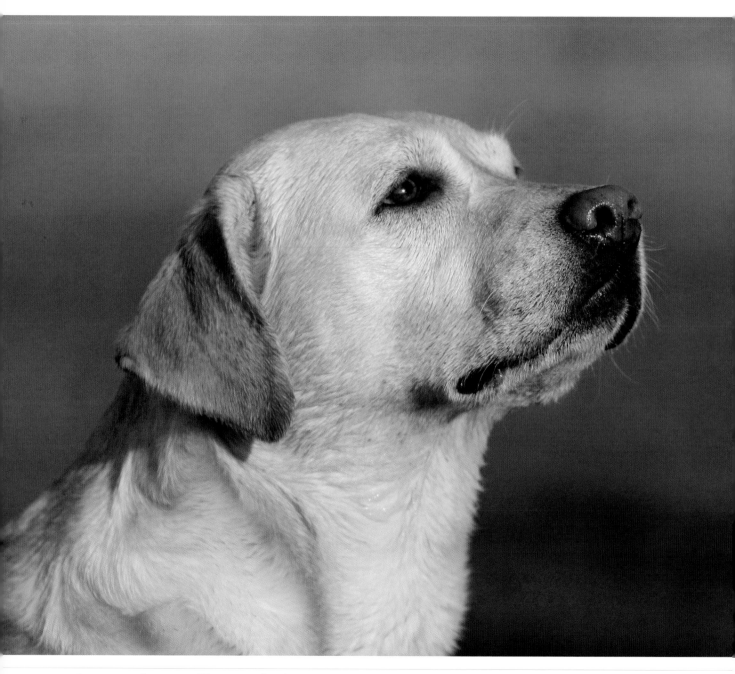

ABOVE AND OPPOSITE: Time to catch a few warming rays of sunshine before setting off again.

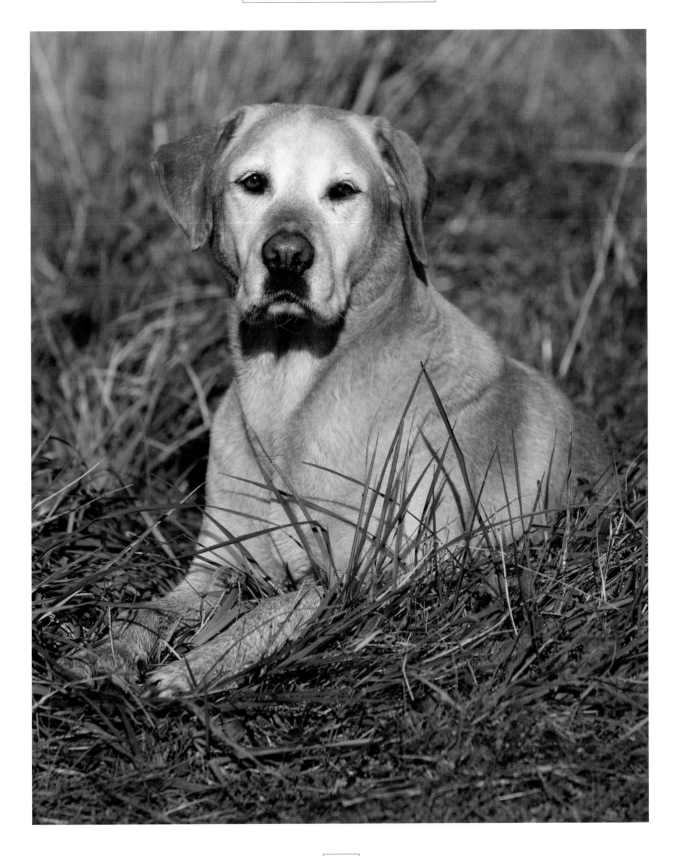

One consequence of growing old is that the once gleaming black or yellow coat starts to turn grey, it happens to all of us but humans can take a trip to the local hairdressers and with a few chemicals turn back the years…. dogs don't have that choice they choose to grow old gracefully!

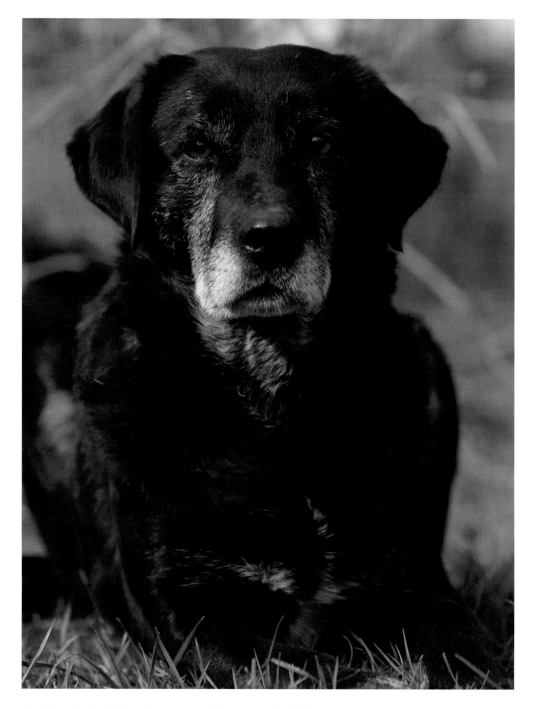

A visit to the local hairdresser in an effort to turn back the years is not an option for this ageing Labrador.

Some black Labradors turn grey from quite an early age and far from spoiling their good looks I think it adds to their air of 'grandness' and my favourite way to photograph an elderly greying dog is to take a side view with the dog looking directly at the owner. This gives the impression of total loyalty and devotion and it works even better if the dog has what I would call an old-fashioned type of head, big and strong and if I can get the reflection of the owner in the dog's eye then all the better. One yellow Lab I photographed sometime ago had been through the wars and had lost an eye during a shooting trip. The dog had gone out for a retrieve and ran into a sharp branch and as a consequence lost an eye, it really is amazing that considering the enthusiasm that Labradors go about their job of work that more dogs don't lose their sight.

It was quite weird photographing this particular dog as my point of focus is always the eyes and of course in this case I only had one to focus upon, the loss of an eye didn't prevent the dog from doing his job although as he was also getting on in years his owner rationed his work through the day.

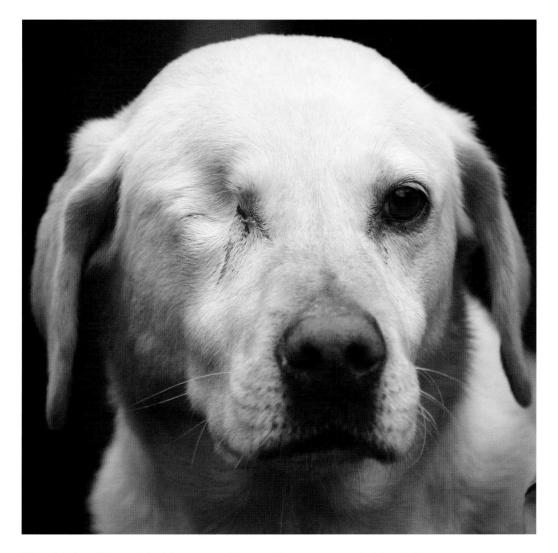

This elderly yellow Lab had lost an eye during a shooting trip and although he was getting on in years he was still able to manage a few retrieves during the day.

Family pet

Back in the mid 1800s when the Labrador first came to the UK from Newfoundland it was brought over as a working dog and even today it has maintained that role as the number one retrieving dog but it is also extremely popular as a household pet and there are probably more Labradors fulfilling this role than as a working dog.

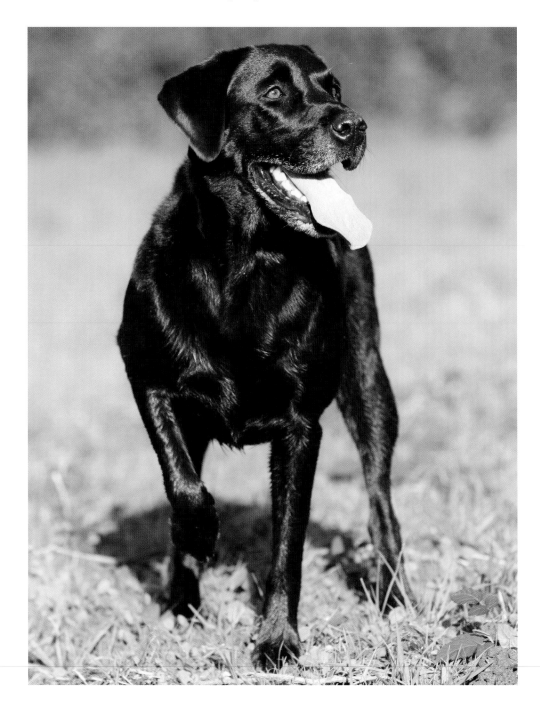

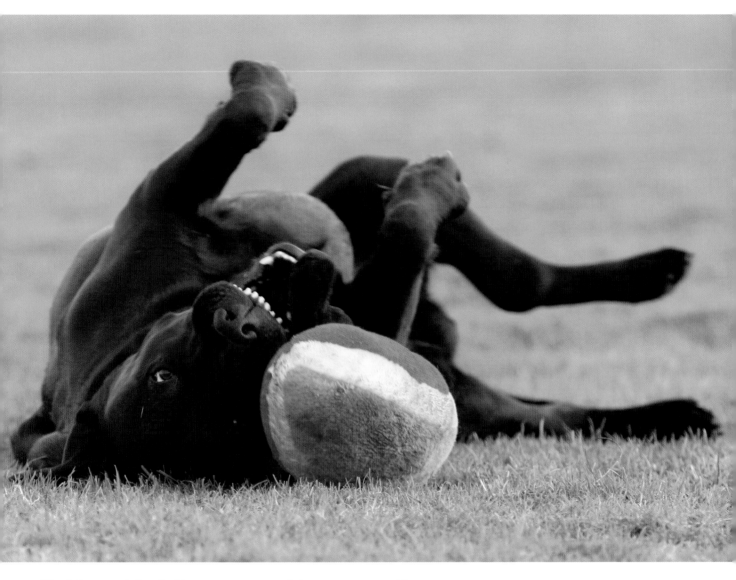

'Don't just stand there looking at me – come and give me a tummy rub'

OPPOSITE: *Taking a quick breather before another game of find the ball.*

As a family pet you would be hard pressed to find a more loyal and faithful companion and Labradors are generally very good with children.

However, despite their domestic duties they still retain their love for playing ball and frantic games of fetch.

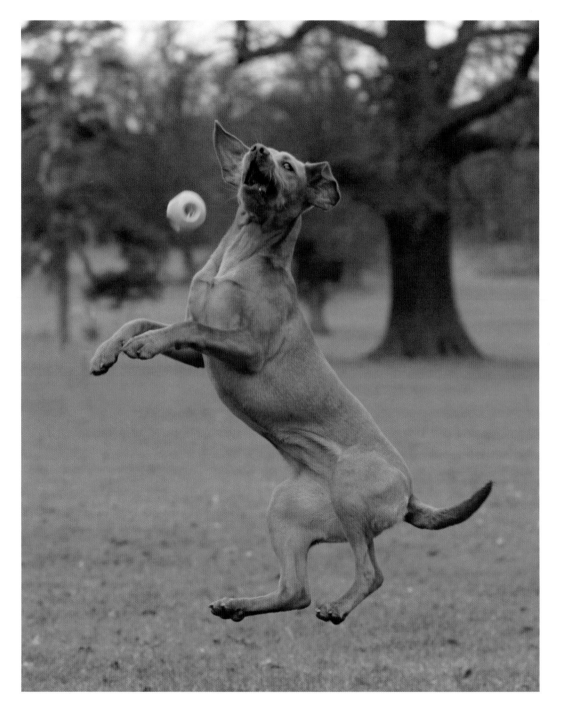

Give a Labrador a ball and not only will he be your best friend but he will also amuse both of you for hours.

Photo techniques

Now I have to say that I never digitally manipulate any of my images that is to say that I would never copy and paste a ball in front of a running dog. My pictures are shot 'as is' so over the years I have had to develop techniques to ensure I can get a flying dog in mid air with a ball that has just been caught or is just about to be caught and I have had plenty of practice to get it right! Despite being quite large dogs, Labradors are extremely athletic and can manage to contort themselves into all sorts of shapes – and just check out those ears.

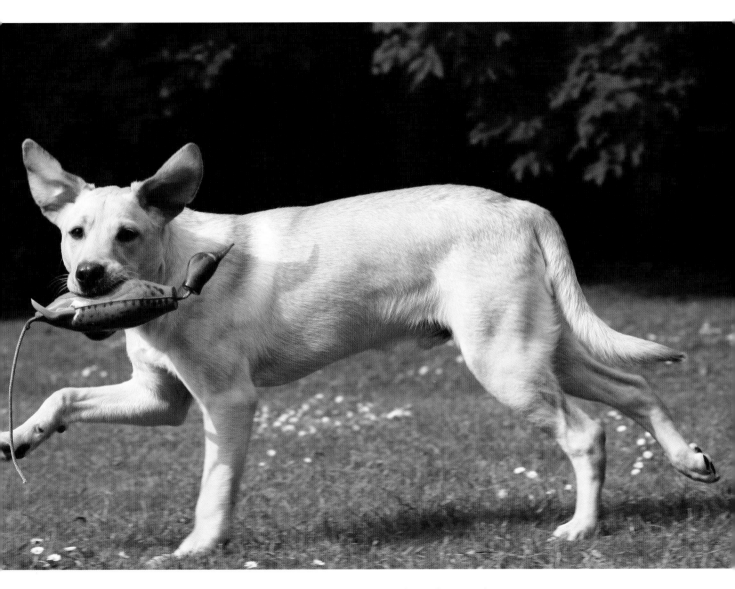

I have checked through the history of the Labrador and there is definitely no dingo in the ancestry...

Many owners, when looking at these kinds of photographs comment that the dog doesn't look like their dog but how often do we see our faithful friend in freeze frame?

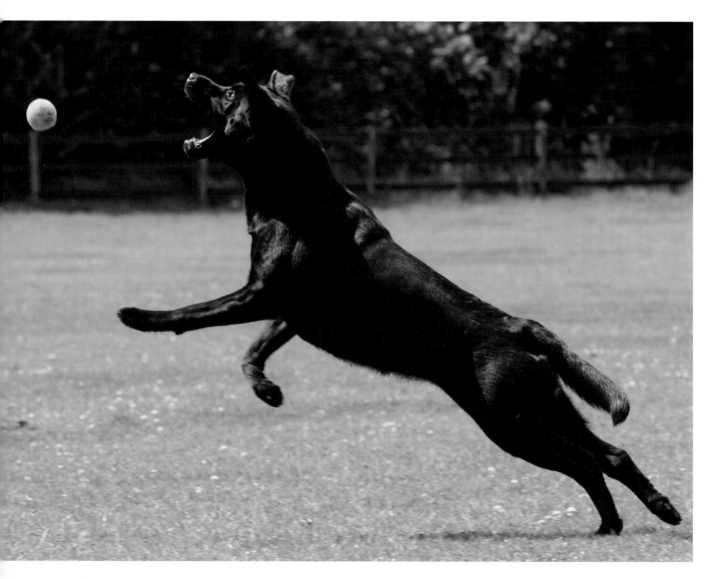

It's mine...

One of the most difficult fun shots to master is trying to get two dogs to jump over an obstacle at the same time and this kind of shot has to be set up and it takes a degree in mathematics and physics to work out the distances that the dogs have to be positioned. The main problem is that one dog will always be faster off the mark than the other one and as a consequence one dog will be in focus whilst the other one will be a blur. These two yellow Labs lived together so there was no problem getting them to jump fairly close together, the problem was that the one on the left was a lot quicker than its companion and it took a good quarter of an hour until I had got the positions right. To capture this kind of image I use a technique called 'pre-focusing' and it simply means that I focus on an area in front of the dogs and then I have to anticipate to fire the camera shutter button when the dogs have reached that point.

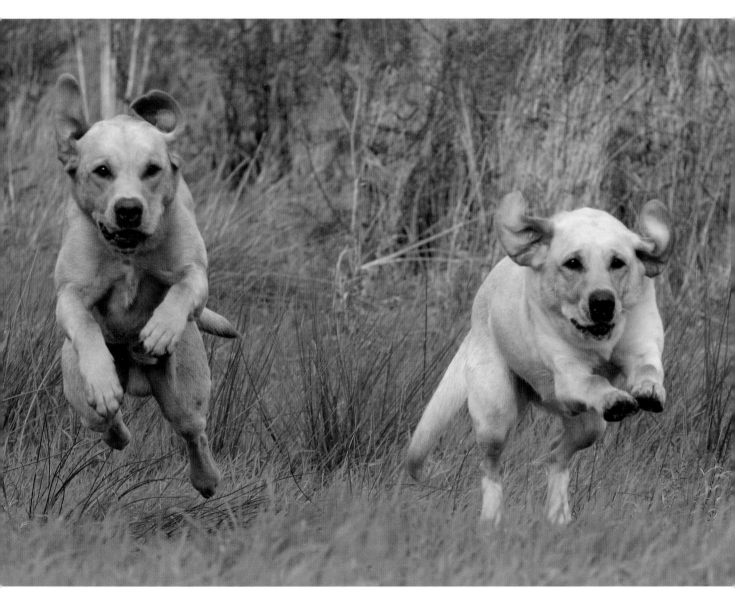

Fun jumping shots can be quite difficult to master especially when there are two dogs...check out those ears!

Once I had got my timing right I was able to get a few images of the dogs and this one is in my view the best. I particularly like the focus of the dog's eyes and of course those ears are just great. For a dog that has relatively small ears compared with a spaniel, Labrador ears do tend to fly around a bit. I reckon they must act as mini air brakes and if they could be kept in place the dog would get another five miles per hour when running!

I think it is quite fitting that the last picture in this book was taken at dusk after a wonderful day's rabbit shooting. From a purely commercial point of view I normally don't include humans in many of my photos, generally people do not like seeing themselves in photographs and therefore tend not to buy them. This Labrador and his handler were standing on the brow of a hill and as the dog came back with a rabbit I again saw the potential image. I knew it would work as a silhouette and as the dog got closer to its owner I fired off a couple of shots and it worked perfectly. There is something very evocative about this image I think it shows the perfect relationship between Man and Labrador... long may it last.

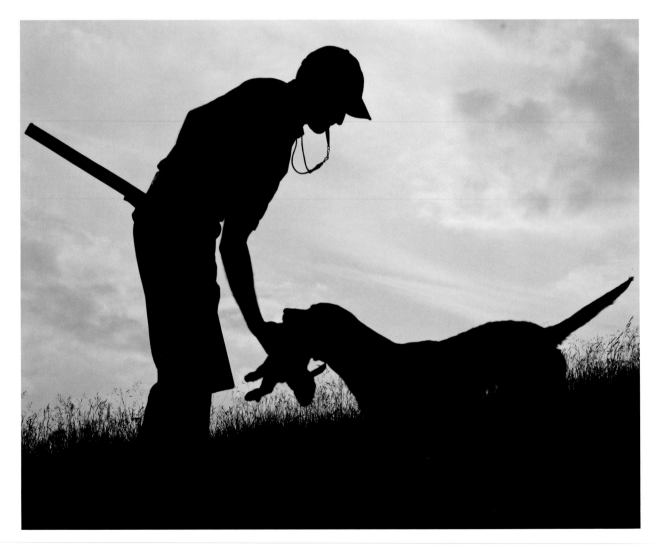

Man and Labrador...the perfect combination.